IMAGES
of America

MANCHESTER

IMAGES
of America

MANCHESTER

Manchester Historical Society

ARCADIA
PUBLISHING

Published by Arcadia Publishing
Charleston, South Carolina

Printed in the United States of America

Library of Congress Control Number: 2010940216

For all general information, please contact Arcadia Publishing:
Telephone 843-853-2070
Fax 843-853-0044
E-mail sales@arcadiapublishing.com
For customer service and orders:
Toll-Free 1-888-313-2665

Visit us on the Internet at www.arcadiapublishing.com

*This book is dedicated to all the residents of
Manchester—past, present, and future*

CONTENTS

ACKNOWLEDGMENTS

Putting this book together gave us the opportunity to view hundreds of photographs in the care of the Manchester Historical Society (MHS). We enjoyed the process thoroughly, although we had to make some difficult choices about what to include. Over the past 100 years, many community members have entrusted their mementos to the society, and we are grateful to them for preserving these glimpses of the past.

We are deeply indebted to the late Mary Bort, curator of the MHS collection for more than 25 years, for her records and newspaper stories and to Nancy Otis, coauthor with Edwin Bigelow of the first comprehensive history of Manchester. Their devotion to telling the story of Manchester is unsurpassed, and we have relied on their research and scholarship to give readers a short description of what each photograph represents.

We very much appreciate the contributions of William C. Badger, AIA, who was so generous with his time and knowledge. He and other members of the society's board of directors were very supportive of our efforts. The staff members of the Mark Skinner Library were also very helpful, and we thank them for their kindness. Additionally, we would like to thank Laine Dunham, curator of Hildene, for responding promptly to our requests; Michael Powers and Terry Tyler for their help in tracking down photographs; Burr and Burton Academy Archives; the Lathrop/Harwood family; and Jake Conte of the Image Loft for his expertise in reproduction. The maps from the F.W. Beers 1869 *Atlas of Bennington County* have been reproduced with the permission of Tuttle Publishing Company.

We also wish to thank our editor at Arcadia Publishing, Hilary Zusman, for her very cheerful assistance and professional guidance.

Unless noted otherwise, all the photographs in this book are from the Manchester Historical Society's collection housed in the Mark Skinner Library in Manchester Village.

—Judith A. Harwood, curator of the Manchester Historical Society
Frederica Templeton
Susanne Washburn

INTRODUCTION

Every historical society shepherds the back story conveyed in documents, diaries, artifacts, art, and (later) photographs. This book's images, drawn primarily from the collection of the Manchester Historical Society, are derived from several types of photography over the history of this modern art form: daguerreotype, tintype, stereograph, glass-plate negative, and then the long-running, more familiar negative image (before the newest digitized version).

From the start of Manchester—created by New Hampshire's colonial governor Benning Wentworth in 1761 among 57 towns in the territory now known as Vermont—there are documents like the original charter, which granted rights to portions of 23,040 acres to 64 individuals. The grantees were land speculators—most of whom never saw the place, their grants sold and resold before genuine settlers came to the frontier location in 1764. Among the earliest were Jeremiah French, Martin Powel, William Marsh, Gideon Ormsby, John Roberts, and Samuel Rose. Within a decade, recent settlers (except Tories French, Marsh, and Rose) were taking part in military action that would become known as the American Revolution. Among the earliest artifacts in the collection of the Manchester Historical Society are a powder horn, marked with the maker's name and the notation, "maid [sic] in 1764;" the nine-inch-long key to the town's first jail; a druggist's small wooden keg; and a perforated metal foot warmer (heat provided by coals) used in a church.

But less than a century later, forms of photography were coming on the scene. Following the daguerreotype (1840s) that was used chiefly for portraits, the handheld stereopticon, or "magic lantern," (1860s) provided a three-dimensional image, or stereograph. In the MHS collection, there are stereographs that illustrate local street scenes and mountain views. The society's archives also include a cache of glass negatives, another development in the technology: these images show lumber mill workers, Civil War–era bandsmen, and railroad gandy dancers, among other interesting perspectives on bygone times.

The majority of this photographic history's offerings picture the town and its inhabitants from the years of the later 19th century to just before World War II. The book embraces the three areas of Manchester: the Village with its commodious "cottages;" the manufacturing core, Factory Point (a name later gussied up as Manchester Center); and the Depot, anchored to the all-important railway connection. Within these designations were districts with names like Barnumville, Richville, Rootville, Beartown, and more.

Early in the photography era, Manchester was emerging as a country resort for people from Boston, New York, Philadelphia, and Chicago who built summer homes in the Village. The William Marsh Tavern of Colonial days was succeeded by two separate, columned hotels catering to summer visitors. These eventually combined to become the Equinox House, the prestigious resort that hosted presidential candidates and first family members. What in the late 19th century was a vacation consisting largely of rocking-chair activity, horse-drawn-carriage tours, and decidedly heavy meals eventually expanded to include pond fishing and golf, for which Manchester boasted standout links. In addition to the Equinox, several other historic inns still grace the town.

In Colonial times the mountains and valleys were heavily timbered with first-growth wood. Soon land was cleared for farming and raising sheep, which led to sawmills and woolen mills. In 1812, Factory Point, downhill from the fine homes in the Village, housed a gristmill, fulling mill (where water treatment cleansed and enhanced wool), carding mill, sawmill, tannery, wagon shop, blacksmith shop, distillery, and tavern. In 1852, the railroad first came to the Depot, leading to interstate transportation for local industry and the arrival of a burgeoning cadre of well-heeled travelers for local hostelries. A tackle shop opened by Charles F. Orvis in 1856 is today a 155-year-old business and a standard-bearer in the field of fly-fishing. In the later 19th century, subsistence farming in the area was shifting to extra-family feeding, and dairying began to take on importance in Vermont. At the beginning of the 20th century, when the marble industry boomed in neighboring Dorset, quarried stone was transported to a finishing mill in Manchester Center via a 5.09-mile railroad. Other mills and finishing plants yoked with different quarries were located in the Depot, hard by the railroad tracks.

Manchester's first survey in 1766 marked out a "lott" for a meetinghouse, eventually an unpainted building devoid of steeple and ornament. As the First Congregational Church (formed in 1780), it was situated not far from its present location opposite the Equinox. Also set aside was a glebe, or farmland, to support the minister. More religious groups followed: Baptists (1781), Episcopalians (1782), Roman Catholics (1896), and the Israel Congregation (1920).

At the center of the Village stands the town's iconic war memorial topped by the figure of an officer of the Revolution. Nearby is a building with a gilt dome that houses the court of the Northshire ("shire" being the British term for "county"). Manchester and the surrounding towns are thus differentiated from the Southshire, the towns surrounding Bennington that have their own court. Early on, Bennington was 1 of 2 two-shire counties in what would become the state of Vermont, but Cumberland County is no more, and Bennington alone retains the two-shire distinction.

The locus of public education was originally the one-room schoolhouse, Manchester's earliest recorded in 1776. At their peak in 1860, Manchester school districts numbered 16. (It would be the mid-20th century before modern busing assembled all the town's children at a central elementary school.) In 1833, Burr Seminary opened as a secondary school for boys, and thanks to the bequest of Josiah Burton, the school welcomed girls in 1849. (In 1999, to ward off mistaken identity, Burr and Burton substituted "Academy" for "Seminary" in its title.)

Numerous social, fraternal, athletic, and civic groups have contributed to the life of the town over its 250 years. Volunteer firefighters were as essential earlier as they are today. Besides the Grand Army of the Republic, the board of trade (precursor to the chamber of commerce), the Masonic lodge, the Eastern Star, the Green Mountain Club, and the Rod and Gun Club, the town's longest-running organization—and still active—is the Monday Club, a group of 16 ladies given to intellectual pursuits.

In preparing this volume, the Manchester Historical Society is indebted to a number of other sources on the town's story (see Bibliography, page 126). Details from these histories, together with the photographs selected, give entrée to the lives and surroundings of the denizens of former times. This book is a salute to the people of the Village, the Center, and the Depot who made Manchester what it was and, in many ways, what it is today.

One

THE VILLAGE, THE CENTER, AND THE DEPOT

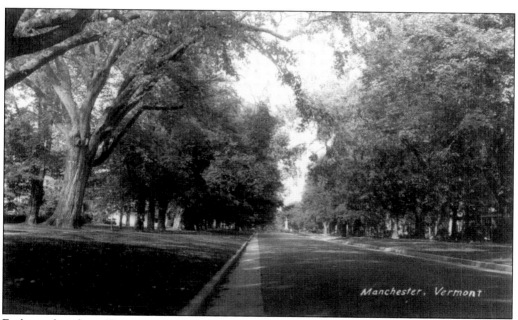

Early settlers from Connecticut brought with them the tradition of broad well-shaded streets. About 1780, Dr. William Gould planted elm trees on either side of "The Street," as it was called by early inhabitants of the Village. The marble sidewalks, first laid down about 1850, exemplified cleanliness and beauty. During the 1890s, with the arrival of many more summer visitors from the cities, the residents removed dilapidated front-yard fences to create an inviting entrance to the Village.

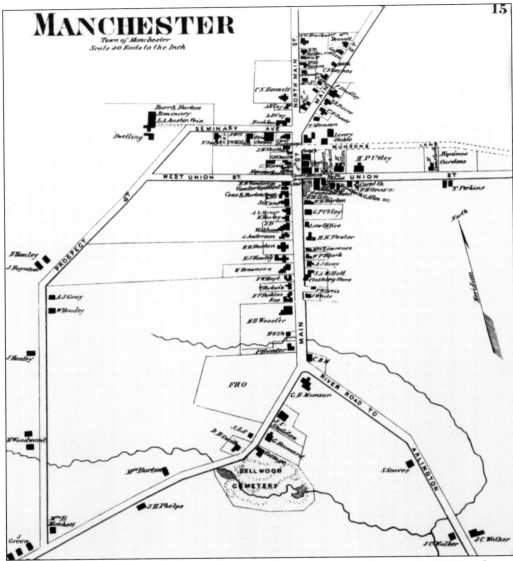

The F.W. Beers 1869 *Atlas of Bennington County* shows a detailed layout of early Manchester Village roads. Defining the boundaries of the Village were the Taconic Mountains to the west, the Batten Kill to the east, and the Glebe Swamp to the north. Five roads provided access to residents and travelers going north or south. Union and Prospect Streets had been opened, and Taconic Avenue would be opened some 30 years later. New roads spread in a spiderweb pattern as far as the physical boundaries allowed. Many of the roads, buildings, and people's names seen on this map turn up in the Village section of this book: Vanderlip Hotel, Equinox's Carsden Inn, Dellwood Cemetery, Burr and Burton Seminary, Episcopal Chapel, Courthouse, Cone and Burton Store, and Manchester Hotel; Gray, Burton, Munson, Hawley, Millett, and Orvis.

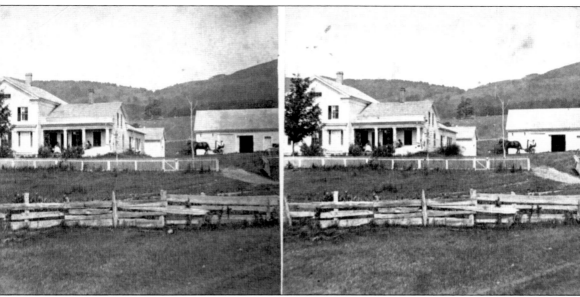

The early settlers, who came from Connecticut and Massachusetts, knew how to raise livestock; cut lumber; build houses, barns, and fences; raise grain crops; produce potash; and forge tools. They established sheep and dairy farms. Around 1795, the Lathrops came to Manchester, purchasing or building houses. This house, built around 1850 by Hubbel Lathrop Jr. just south of his father's home on the Sunderland town line, remains a fine example of the Greek Revival style. Supported by a marble-faced foundation, the post-and-beam house has clapboard siding and an earlier wood-shingle roof with a slate roof added over it. Large barns housed cows and sheep. Picket and wood-slab fences dotted the landscape. Outbuildings—aptly named chicken coop, corncrib, milk house, and piggery—sheltered animals and crops. The Lathrops raised merino sheep throughout most of the 19th and early 20th centuries. To supplement their income, they, like other farmers, sold distilled whiskey and natural resources, such as marl. (Courtesy of the Lathrop/Harwood family.)

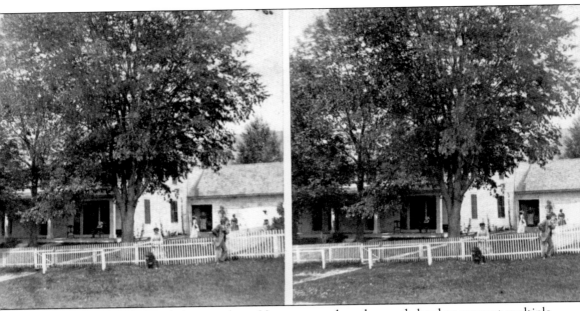

Many farmers who settled in southern Vermont purchased enough land to support multiple generations. Aaron Mason first settled on a 50-acre lot near the Manchester-Sunderland line. A New York emigrant of Dutch descent named Issac Brevoort purchased the lot from Mason and, around 1774, built this house, which is still standing. The house has a stone foundation, post-and-beam frame with a wood-shingle roof, and a later slate roof covering. Eli Lathrop purchased this house and some surrounding acres when Brevoort left in 1776 to fight in the Revolutionary War. Later, Hubbel Lathrop Sr. lived on what is now called Lathrop Lane with his wife and spinster daughter until his death in 1842. His wife and daughter lived here until the mother's death in 1841, when the daughter moved across the road and the house was sold. A one-story, wraparound porch once embellished three sides. Evidence of a massive central chimney, extensive stenciling, and beaded beams can still be found. (Courtesy of the Lathrop/Harwood family.)

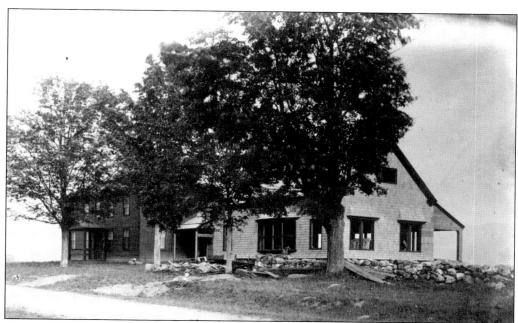

Thomas Purdy built this early Federal-style house (later used as a tenant house by Major Hawley) around 1800. Edward Swift Isham purchased it in 1885 to use as his summer home. A law partner of Robert Todd Lincoln in Chicago, he built an elaborate Queen Anne–style carriage house and a group of outbuildings behind it, north of the main house. In 1900, Isham installed an electric-light plant for his house, the first recorded use of electricity in Manchester. He named his home Ormsby Hill after the Revolutionary War patriot Gideon Ormsby. This group (below), guests of Edward Isham, enjoys the panoramic views of the Green Mountains at an afternoon lawn party. The Ormsby Hill house is now an inn, while the farm fields have been subdivided into house lots.

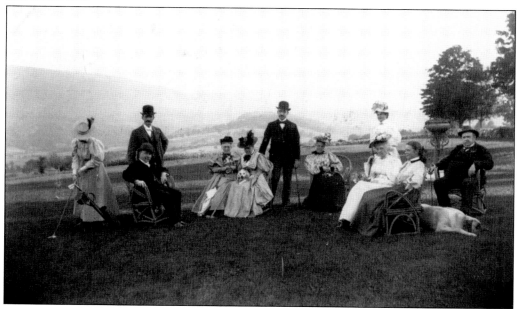

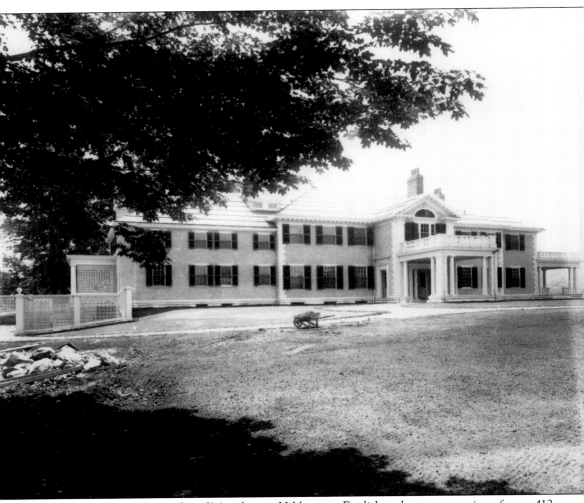

Located at the southern edge of Manchester, Hildene, an English-style estate, consists of some 412 acres, the main house, a carriage house, and numerous outbuildings. Robert Todd Lincoln, son of Pres. Abraham and Mary Todd Lincoln, spent the summers of 1863 and 1864 in Manchester at the Equinox House. His fondness for Manchester, and the fact that his law partner Edward Swift Isham had a house here, resulted in his building Hildene as his summer home. The Georgian Revival–style mansion was completed in 1905, and Lincoln spent every summer here until his death in 1926. William Howard Taft stayed at Hildene in October 1912. In 1938, Lincoln's granddaughter Mary Lincoln "Peggy" Beckwith inherited the home. She practiced conservation, ecology, and sustainable farming. An avid aviator, she housed her plane in a hangar on the lower meadows. She died in 1978. The estate is currently owned and operated by the nonprofit Friends of Hildene.

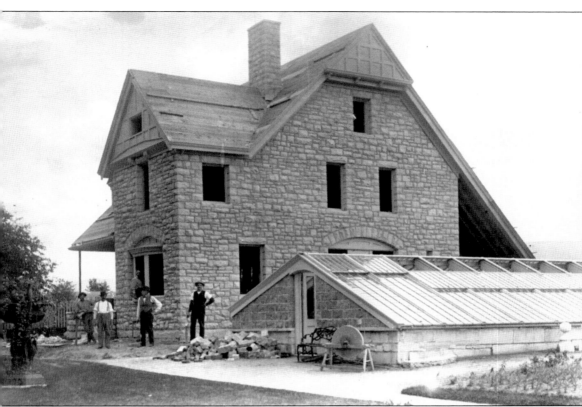

Early cemeteries had no designated caretaker to tend the grounds; rather, families of the deceased cared for the plots as they wished. As a result, maintenance was poor and sporadic until the position of cemetery superintendent developed to provide orderliness. These men provided graveyard maintenance and landscape gardening. Pleasant and peaceful surroundings evolved with the addition of winding roads, fountains, and ponds like those found in Dellwood Cemetery. Mark Skinner's generosity and influence made Dellwood one of the most modern cemeteries of its time. When it was enlarged between 1850 and 1860, the lot just to the north was purchased. Later, the small dwelling and old greenhouses were torn down and replaced by a cottage of blue limestone quarried off the Manchester West Road. Its superintendent used the house as his home. New greenhouses were built to provide flowers for the cemetery, as well as commercial sales. The house is now a private home; the greenhouses are gone.

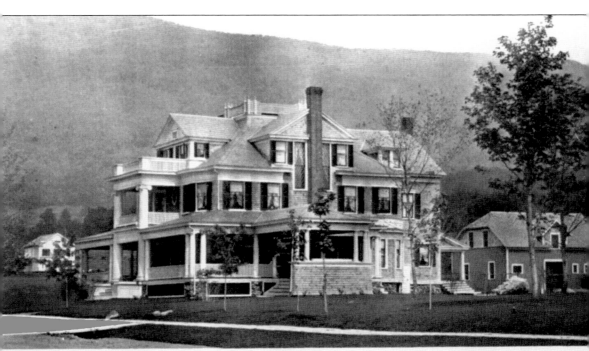

THE COLONIAL—For Sale or to Rent— Extended mountain views all sides. looking Golf Course. Twenty-[...]s, all modern conveniences. Three bath rooms. Electric lights and bells. Fine wide verandas, three sides. Stable fo[...]s and automobile. Fully furnished for renting. Apply to owner, C. H. HAWLEY, Manchester-in-the-Mountains, VERM[...]

Since the 1850s, summer visitors had stayed in local hotels, boardinghouses, or homes. By the late 19th century, many regular visitors began acquiring lots and building summer residences. Several new and larger houses were built to accommodate their families, servants, and guests. About 1899, the Hawleys opened up a new road—Taconic Avenue, from Main Street to Prospect Street—to cottage building. The Colonial (pictured here) is an example of a surviving "cottage." An advertisement in a 1903 pamphlet listed The Colonial as "for sale or to rent, extended mountain views on all sides, overlooking golf course, twenty-three rooms, all modern conveniences, three bathrooms, fully furnished for renting, electric lights and bells, fine wide verandas, three sides, stable for six." The five initial cottages built are still standing.

About 1790, Israel Roach built this Federal-style house as his tavern and home. The building has served as a select school, a shoe shop, and a poultry business. At one time, possibly as many as nine families lived here. Later, William A. Burnham (1805–1860) owned the house. He taught English and served as assistant headmaster at Burr Seminary from 1835 to 1860.

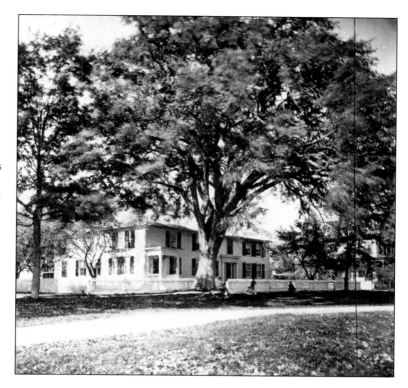

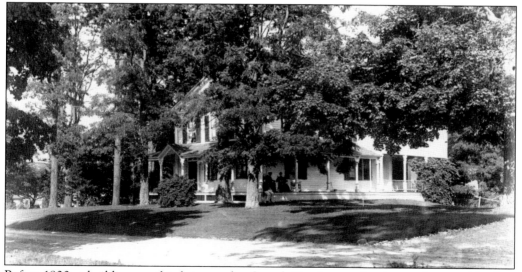

Before 1800, a building on this lot served as Joseph Burr's store, but it was destroyed by fire. Charles Bennett built this house about 1860. It was later the home of E.J. Hawley, who sold the Italianate Revival–style house to Mrs. W.H. McClure of Albany. The house was moved back, the land regraded, and the roof raised. Peter H.B. Frelinghuysen of New Jersey purchased the house in 1954.

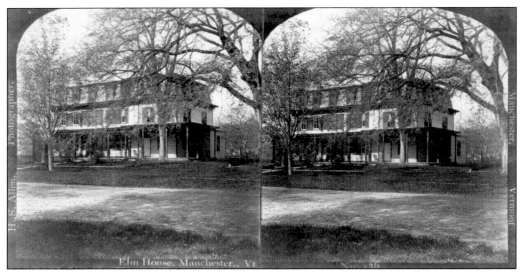

Dr. W.A. Brown purchased this house, built by Serenus Swift around 1800. In 1870, Brown rented it to Charles F. Orvis, brother of Franklin. At his summer boardinghouse known as The Elms, Charles catered mainly to men who wished to fish but welcomed families as well. Around 1883, Dr. Brown added an extension to the north. In 1954, the house was purchased by Peter H.B. Frelinghuysen and torn down.

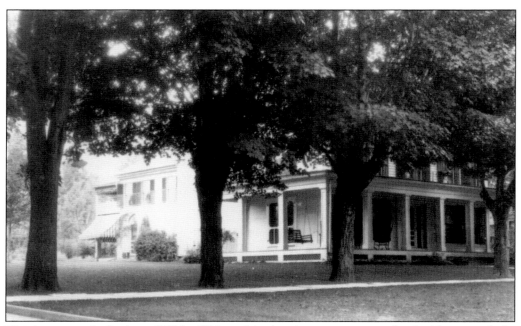

This house was built about 1769 by William Marsh, who ran a tavern a few buildings north. In the 1790s, Robert Pierpont operated it as Pierpont Tavern, and later Capt. Peter Black ran it as Black's Tavern. Dr. Joseph D. Wickham, headmaster at Burr and Burton Seminary, purchased the house in 1864 following his retirement. The house is still owned by his descendants.

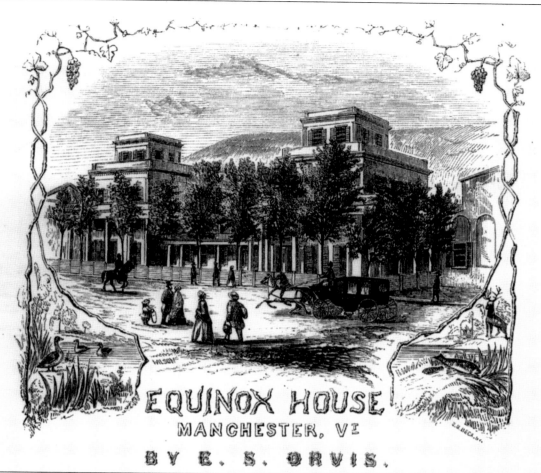

EQUINOX HOUSE
MANCHESTER, VT.
BY E. S. ORVIS.

Many early settlers, including Levi Orvis, traveled north and west across the Green Mountains from the east to settle in Manchester. Orvis purchased lot No. 2 and built a store and an expansive home north of it. After Levi's death in 1849, his son Franklin returned to Manchester, bought his father's home and store, enlarged the buildings, and opened it as the Equinox House in 1853. He added room capacity when he purchased the Vanderlip Hotel and connected the three structures with a second-story walkway. Ever attentive to the needs of his guests, he provided a driving map, carriage rides, golf, canoeing, fishing, swimming, lawn tennis, rockers just for sitting, and entertainment. In 1863 and 1864, Mary Todd Lincoln spent two weeks at the hotel with her son Robert Todd Lincoln. About 1886, Franklin added amenities like running water, bathrooms, and steam heat. The Equinox House stayed in the Orvis family until 1938, when bankruptcy dissolved the company.

Main St., Manchester, Vt. No. 27

Marble quarrying became an important industry for Manchester and Dorset in the 19th century. Scrap marble from the finishing process was readily available and used in the foundations of many buildings. The irregular ends of large blocks sawed in the Factory Point finishing mills became useful to the thrifty settlers. Levi Orvis, father of Franklin and Charles, noted the dirt and mud soiling the long skirts of his wife and daughters. He likely purchased the scrap ends and directed that marble sidewalks be laid in front of his home, which later became the north end of the Equinox House. He also added small marble platforms in front of his store to assist women ascending and descending carriages. What Levi began as a simple solution to a problem resulted in nearly four miles of marble sidewalks being laid in the Village and then in Factory Point. The marble walk, shown here in a c. 1880 stereograph, was straightened in 1911.

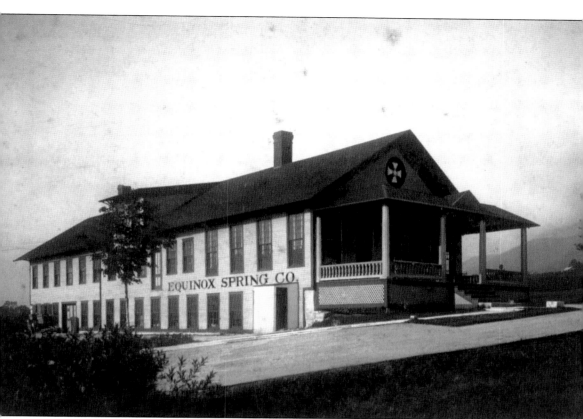

The 3,850-foot Mount Equinox, the tallest mountain in the Taconic Range, rises in a westerly direction from the Village. Early settlers found an abundance of natural springs on the mountain. Capitalizing on this water source—even though some considered the water unfit to drink—the Equinox House supplied its guests with pure spring water. The hotel corporation next opened the Equinox Spring Company in a building west of the hotel. It bottled, packed in wooden crates, and shipped its water—along with water-based effervescent soft drinks, ginger champagne, and sparkling water—to customers within and beyond Vermont. For a time, the company also shipped large quantities of sausage. The water company ceased operations around 1920. In 1927, the building was remodeled as a dormitory for men who worked as waiters at the Equinox House. The structure shown no longer exists.

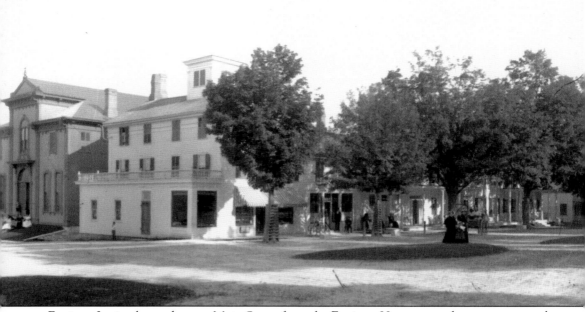

Equinox Junior, located across Main Street from the Equinox House, served as an annex to the hotel. Originally it consisted of four distinct buildings. Thomas Purdy and Thomas Straight operated a tavern, which later served as the courtroom and jail. The pressroom of the *Manchester Journal* and Seth Lyon's residence completed this cluster. The corner of Main and Union Streets was occupied by the Manchester Hotel built by Franklin Orvis; it opened in April 1863, adding 60 hotel rooms. The space on the second floor had earlier included the rooms of Dr. L.H. Sprague's water cure; his patients stayed across the street at the Equinox House. In 1866, Franklin Orvis consolidated these buildings into a structure he called Equinox Junior, a name used to this day. The component parts vary in roof ridges, and the two gable-end buildings are topped by square belvederes with louvered openings, which promoted cooling ventilation during the heat of summer. The row is privately owned today.

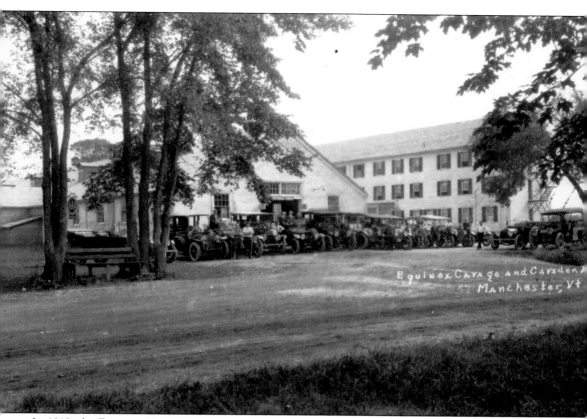

In 1912, the Equinox House owners built the Carsden Inn on Union Street to accommodate the grooms and chauffeurs of the guests who came to Manchester for prolonged stays. One hundred rooms housed the men, and a livery provided services for horses and carriages kept in a large barn. When a new form of transportation succeeded them, a fireproof garage was built to provide storage and service for automobiles, which by 1912 were relatively common. As tourists built their own summer homes, the need for the garage diminished. In 1937, the Winter Sports Club sponsored an indoor skating rink there for one year. A space measuring 170 by 40 feet was iced, and a heated dressing room was provided. In 1938, the skating rink opened again after $500 was voted by the town for maintenance. Clifford B. Graham, Harry Mercier, and Bryce Tuttle managed the rink from 1938 until 1950, when the town voters refused to appropriate funds.

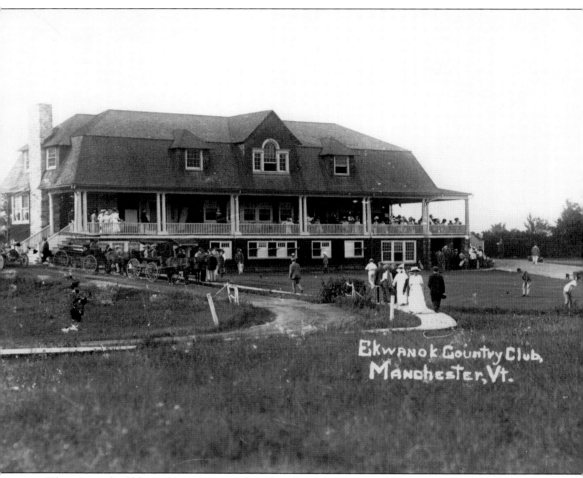

Ekwanok Country Club, Manchester, Vt.

The game of golf, brought to America from Scotland, became popular among the summer residents in the 1890s. In 1894, George Orvis laid out a crude six-hole course behind the Equinox House. In 1896, he and an interested group developed the Hillside Golf Club a little east of Union Street. James L. Taylor of Brooklyn, New York, visited Manchester in 1899. Determined to make the town a golf mecca, he bought enough farmland north of River Road to develop an 18-hole course and clubhouse. His idea found favor with his friends, and a corporation was formed to carry out plans for the new golf course. Walter J. Travis and Scotsman John Duncan Dunn were chosen to design the course. The three-story clubhouse designed by Philadelphia architect Horace Sellers was completed in July 1900 under the supervision of Manchester builder Hiram Eggleston. It included a pro shop, locker rooms for men and women, a ballroom, men's and women's lounges, and a kitchen. Pres. Bartlett Arkell oversaw the building of a new clubhouse when the original burned down in 1938. The Ekwanok remains a private club.

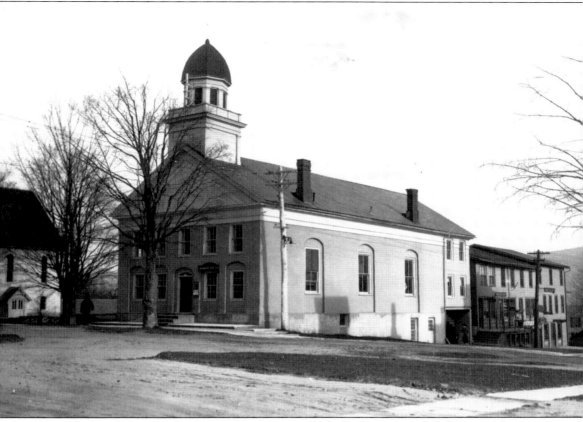

In 1781, the town's first courtroom was located in one of the buildings now called Equinox Junior. To meet the need for more space, the current courthouse was built in 1822 with funds raised through public subscription. The Federal-style building was expanded and remodeled at county expense in 1849. A gold-leafed octagonal bell tower tops the building, although it was merely painted gold until a generous Equinox guest noted its poor condition and had it completely rebuilt in the 1990s. During the Civil War, a regiment recruited from the Northshire gathered in Manchester, and those unable to return home at night were quartered here. Prior to 1868, most Village entertainments were held in the courthouse. In 1898, the Mark Skinner Library rules provided free library cards for officers and jurors of the county court while in session. Because Bennington County had two shire towns, Manchester became known as the Northshire and Bennington the Southshire. Initially, summer court was held in Manchester and winter court in Bennington. Court sessions continue to be held in both communities.

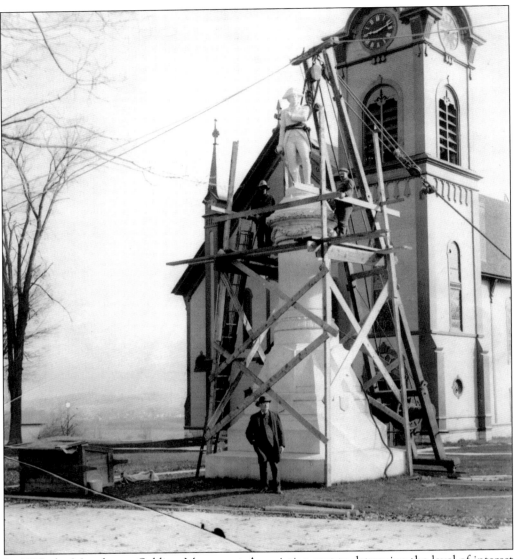

In 1895, the Manchester Soldiers Monument Association met to determine the level of interest in erecting a monument to commemorate the service of its citizens in all wars up to that time. Through subscriptions and donations, and especially funds from Franklin Orvis, sufficient money was raised to begin work. The fine granite statue was made in W.H. Fullerton's shop in Manchester Depot. He created the design, prepared the model, and cut the figure. In December 1897, nine teams of horses labored to haul the base from the Depot to the village green. After the base was set, the 13-ton figure was placed on top, so by 1899, the Continental soldier stood tall. Although many might prefer that this soldier represent Ethan Allen, he was representative of every Colonial soldier. He is shown with drawn sword and a determined expression. The names inscribed on bronze tablets honored all veterans who had served up to 1905.

This land changed hands four times before Jeremiah French Sr., an early settler of Manchester, came into ownership. He built the house about 1770. As the Revolutionary War raged, he sided with the British, becoming a Tory and fleeing to Canada. The Republic of Vermont confiscated his house, property, and lands. Jared Munson bought the property from the Republic, extensively renovating the building. He raised it to two and a half stories. This Federal-style house became the Munson House in 1811, offering accommodations to guests. In 1905, Charles Isham, secretary to and son-in-law of Robert Todd Lincoln, purchased it. After her husband's death in 1919, Mary Lincoln Isham and her son, Lincoln Isham, lived here until her death in 1939. Henry Robinson operated the property as the 1811 House and built the adjoining cottage for his mother in 1941. The Equinox Hotel now owns the 1811 House and cottage.

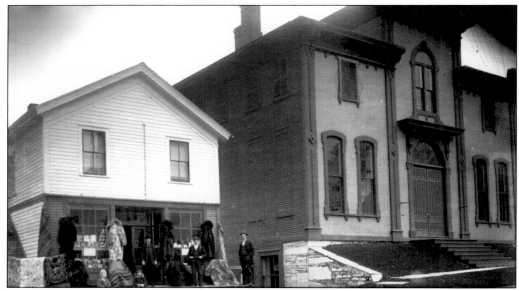

To provide additional entertainment for his guests, Franklin Orvis built the Music Hall (right) on Union Street close to the Equinox House in 1868 at a cost of $16,000. Billiards, bowling, dancing, and an auditorium for stage productions became available. Entertainers included lecturers, vocalists, opera companies, dramatists, magicians, and minstrels. The $60 fee was waved for community events, church services, and Burr and Burton Seminary. The building stands vacant today.

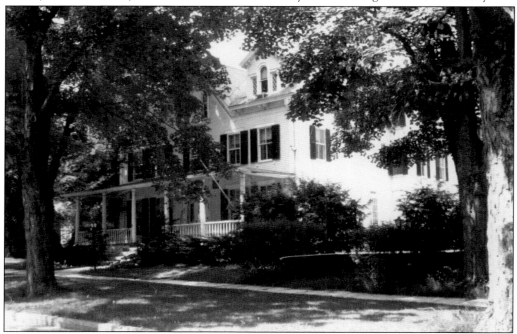

In 1883, Charles Orvis purchased this house to serve as his residence and as a summer boardinghouse known as the Orvis Inn. Around 1935, New Yorker John Ortlieb arrived to ski and stayed at the Orvis Inn. He leased the inn in 1940 and bought it two years later. Known today as the Charles F. Orvis Inn, it has been completely renovated and is part of the Equinox Hotel.

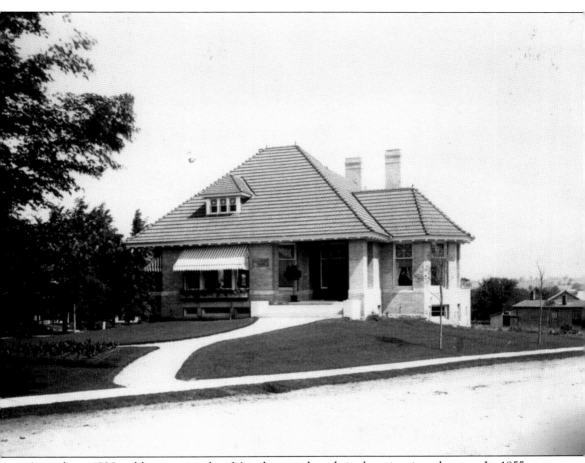

As early as 1828, a library existed in Manchester, though its location is unknown. In 1855, a corporation was formed to administer the Burton Pastoral Library established by Rev. James Anderson of the Congregational church. By 1900, it had over 1,000 volumes, mostly sectarian in nature. In 1889, Frances Skinner Willing, wishing to establish a library in Manchester in honor of her father, Mark Skinner, purchased land at the intersection of West Road and Main Street from D.K. Simonds, whose house was moved across the road. The architect was Stickney of Chicago and the contractor Bellingswood from Massachusetts. In 1897, the 12,000-volume library was dedicated. Mrs. Willing stipulated that the book fund be derived from the public through the sale of library cards and the presentation of frequent and elaborate entertainments. Anniversaries have been celebrated, the 100th being the latest. Today, the Mark Skinner Library is a public institution.

While the new building was under construction in 1896, library services were provided at various locations in the Village. Work completed in May included the reading room and office, and in June, the grounds were graded. Oak furniture, chosen to match the wainscoting, began to arrive in January 1897. The 25th anniversary celebration was held in July 1922 in the reading room.

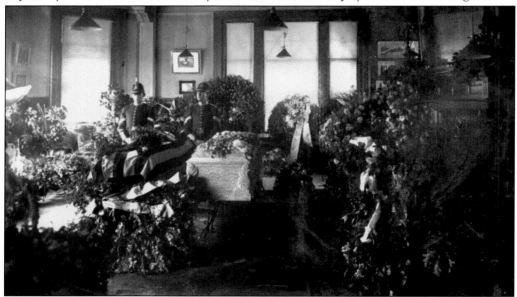

Harris Lindsley of New York City and his fiancée, Evelyn P. Willing (daughter of Frances Skinner Willing, granddaughter of Mark Skinner), were killed near Bennington, Vermont, on August 14, 1905, when a train struck their automobile. He was killed instantly, and she survived only a few minutes. After lying in state in the Mark Skinner Library, they were buried in Dellwood Cemetery on August 21, 1905.

FACTORY POINT
Town of Manchester
Scale 80 Rods to the Inch

Known as Mead's Mill in the late 18th century, Factory Point was aptly named for the industries located there in the 1800s. This early map of the area appeared in the F.W. Beers 1869 *Atlas of Bennington County*. It shows the location of businesses along Route 7A, called Main Street, and Route 11/30 alongside the Batten Kill, then known as the Flat Road and built in 1853. Timothy Mead had a gristmill on the west branch of the Batten Kill and owned most of the surrounding property. He refused to sell any of his holdings, so this area of Manchester remained undeveloped until the late 1830s. The name Factory Point would be changed to Manchester Center in 1886 to avoid giving the wrong impression to the burgeoning stream of summer-resort visitors coming here to breathe clean mountain air.

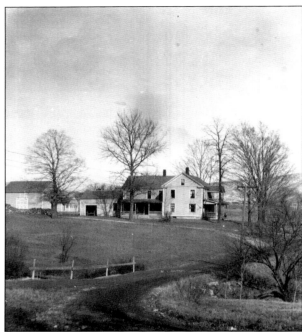

In the early 1800s, what is now Route 7A ran along today's Manchester West Road because the land to the east was too marshy for a road. The only way to get to Factory Point from the Village was over a narrow road cut in a little north of the current Ways Lane, which recalls Lyman Way, who operated the first marble mill in Manchester on the stream there.

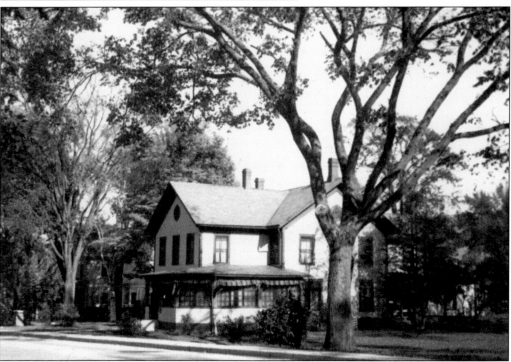

After a road connecting Manchester Village to Factory Point was built in 1812, many fine houses followed as the 19th century progressed, some of which are still standing, though altered. E.L. Wyman built this house in 1872 for his family, and it was still a private home when this photograph was taken in the 1930s. Like many others along this route, it eventually became a store.

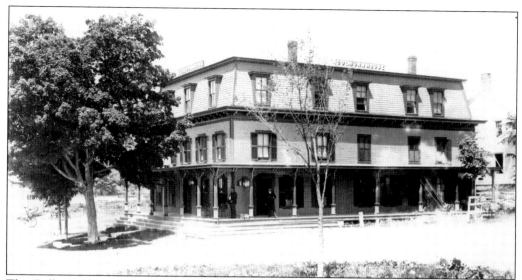

The Colburn House opened as a hotel in 1872 on the site of the first tavern in Factory Point, which had been kept by Martin Mead. It had originally been a farmhouse until it was rebuilt, for Cyrus Roberts, with a dance hall occupying the third floor. The hotel with its restaurant was a popular gathering place for a century and remains so today as the Northshire Bookstore and Spiral Press Café.

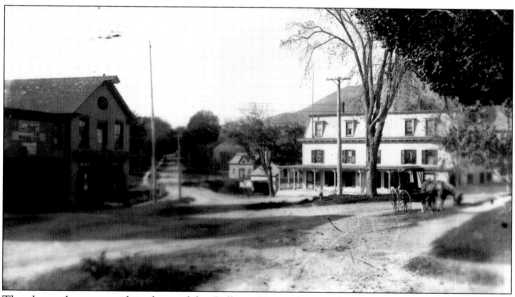

The elm at the crossroads in front of the Colburn House (pictured around 1895) was for many years the landmark at the intersection of Main and Bonnet Streets. Coming from the south, travelers on what was then Route 7 would have crossed the Batten Kill over a wood-plank bridge. In 1884, the original bridge was replaced by a substantial iron bridge, and in 1912, that was replaced by a marble bridge.

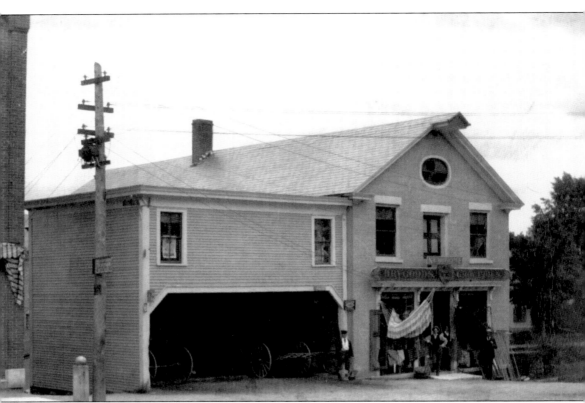

The business that became the Combination Cash Store, shown in this c. 1890 photograph, had been built as a general store by Myron Clark in 1837 on the east side of Main Street. It passed to successive owners and at one time was a branch store of Cone & Burton in Manchester Village. It was subsequently purchased by employee Allen L. Graves, who operated it until 1909, when he sold the store and the livery stable to Manley & Gorton. The new owners tore down the stables and added a grocery department. The Manley family continued to operate it as a general store until the late 1960s.

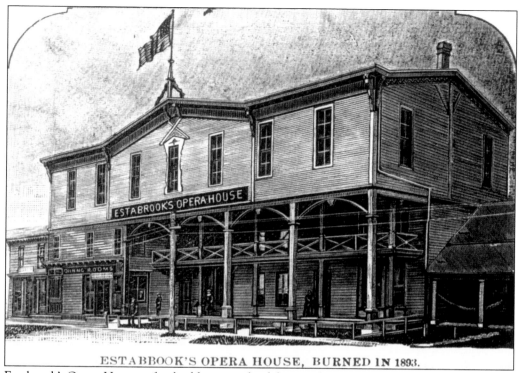

ESTABBOOK'S OPERA HOUSE, BURNED IN 1893.

Estabrook's Opera House, a few buildings north of the Combination Cash Store on Main Street, was originally a tavern built in the early 1800s. Emerson Estabrook remodeled the third floor and opened it as an opera house in 1884. Six years later, the building burned down, along with others on the block. It was rebuilt in 1896 and, after being home to several different businesses, became the final location of the Factory Point National Bank.

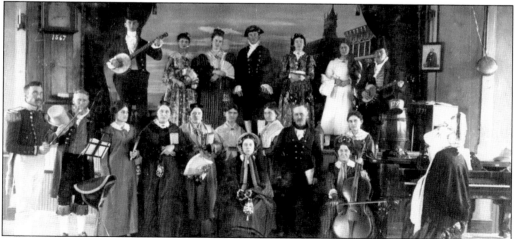

This photograph, entitled "Old Folks Concert," shows the interior of the opera house in the late 1880s. Community members shown are, from left to right, (seated) Mrs. Charles Ames and Mrs. W.A. Adams; (second row) ? Johnson, W.A. Adams, Flora Marsh, Mrs. Baker Nilson, Mrs. Arthur Adams, Delia Smith, Emily Perkins, Thomas Hoyt, and Jennie Hilliard; (third row) Ernest Lugene, Junia Lugene, Anna Ames, Roy Linsley, Ella Dyer, Susie Adams, and Arthur Adams.

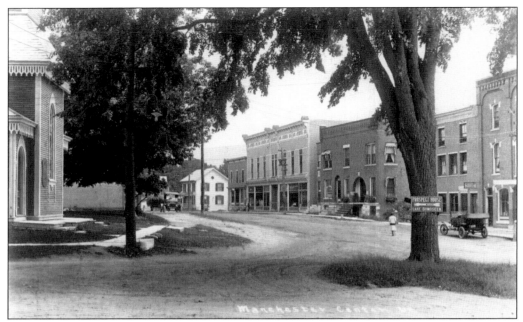

Main Street became the commercial center of Factory Point, with many small businesses along both sides of the street. Concrete roads did not exist in the area until the 1920s, and dust and mud presented constant travel hazards. Sprinkling carts were relied upon to keep the dust down. At a special town meeting in May 1931, voters approved an annual tax of 6¢ for six years to extend the concrete road from the bridge to Barnumville Road.

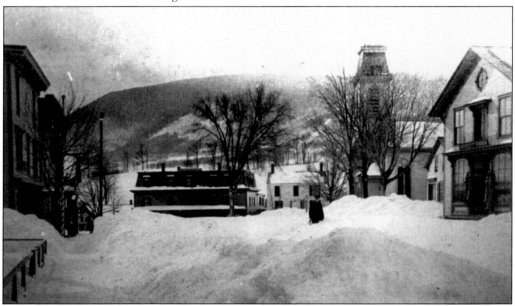

Looking south on Main Street in this 1890s photograph, one can see the roofline of the Colburn House and (on the right) the First Baptist Church, which has occupied this location since 1833. Snow was cleared with the use of horse-drawn plows and large rollers that packed it down sufficiently enough for horses and sleighs to travel.

The road going west to Dorset from the elm at the crossroads was originally named North Street. In the early 1800s, all the land along this road was farmland owned by Gilman Wilson, a successful businessman who owned two marble mills and a large farm on Barnumville Road. The road was constructed in its current location in the 1850s. The first two houses on the left were owned for many years by members of the Wilson family, and a great-granddaughter, May Wilson, lived here well into the 20th century. In the late 19th century, it came to be called Bonnet Street because many fashionable milliners lived in the charming Victorian cottages being built at that time. Milliners Winnie Cook, Clara Lathrop Hanaman, and Mrs. Blackmer and hatter Carson Meacham managed successful businesses from their homes. In this photograph from the 1890s, a few houses can be seen in the background. The young lady may have been a member of the Rowe family, whose house, just behind her, was built in 1856.

In this view of Main Street from around 1920, the building on the left is Heinel's Store today. On the right, many early homes were still in place at that date. A few of them were moved back from the road and turned into stores when a shopping center was built on the west side of the street in the 1960s. The large white house at the right (center) belonged to the Dyer family, who had owned large tracts of land in this area for generations. Known as The Landmark, it was operated as a gift shop at one time. The house was moved to a property off Barnumville Road in the early 1960s and saved from demolition. The marble retaining wall on the left is no longer visible, as commercial development continued to modify the streetscape.

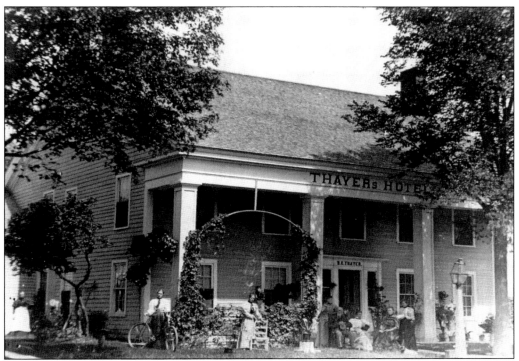

This building, still standing on the west side of Route 7A going north, is thought to have been constructed in 1790 by Aaron Sheldon of Dorset. It was enlarged and remodeled in the 1840s. It had a ballroom on the third floor, complete with a spring floor, a small stage, and tiny dressing rooms tucked under the eaves. In the photograph from the 1880s (above), it is called Thayer's Hotel, but it had also been know as the Stagecoach Inn. Thayer's Hotel at this time was one of the first public places to have a telephone line. In the c. 1899 photograph below, the hostelry is called the Fairview. The men are identified as (left to right) Charles Ames, L. Bulkley, and Pat Phalen.

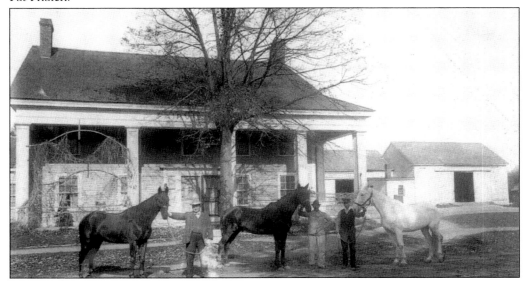

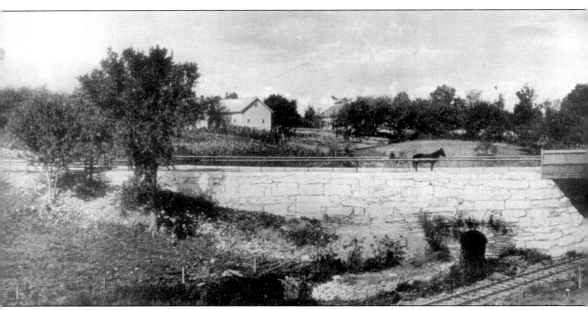

This rare c. 1905 photograph shows the so-called "Marble Bridge" built in 1903 across the gulf on Barnumville Road (originally know as East Main Street). Replacing an original wooden structure, it was wide enough to span the track of the new Manchester, Dorset, and Granville Railroad, which carried marble and passengers for five miles between South Dorset and Manchester Depot in the early years of the 20th century. The road led to the hamlet of Barnumville, which grew to

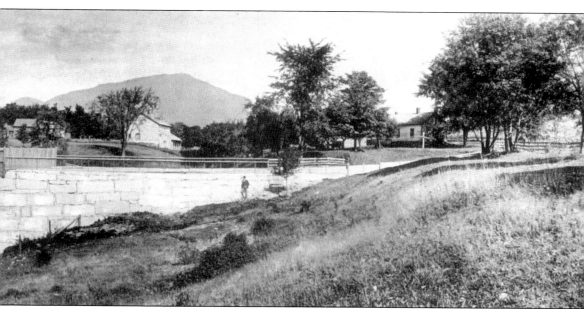

be an important economic center after it became the rail shipping point for large quantities of charcoal destined for the Barnum Richardson Company iron furnaces in Connecticut. For many years, it even had its own post office. The Brick Tavern, originally built in 1825 as a stagecoach inn, is now a private home and can still be seen not far from the railroad tracks.

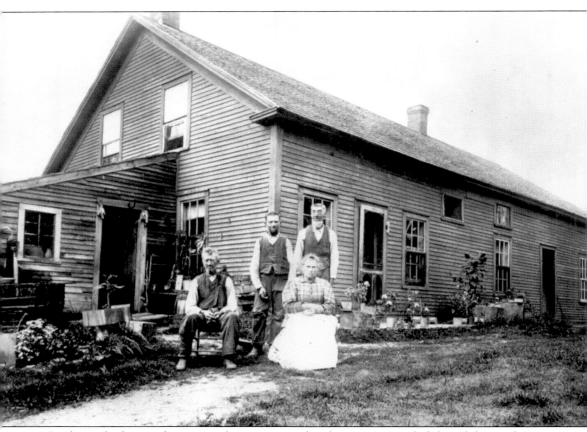

In the early days, indigent people were warned to leave town, and if they did not, the town government had no responsibility to care for them. Another method of dealing with anyone unlucky enough to have no source of income was to put that person up for vendue, or sale, to a local citizen who promised to take care of the individual. By the 1820s, the town voters had agreed to a tax to support the poor and to rent a house for them. Joseph Burr, a wealthy merchant who never married, provided for many bequests in his will of 1828. In addition to the academy that bears his name, he left $1,200 for the purchase of a poor farm, which his executors accomplished in 1829. The town farm shown in this photograph from around 1890 remains in its original location southeast of the Village off Richville Road and is currently a private home.

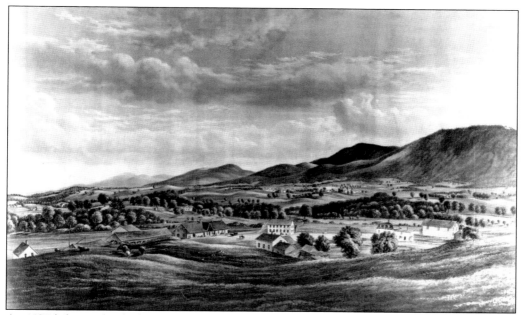

An 1872 lithograph of a drawing of the Manchester area, from the perspective of a hill northeast of the Depot, shows Mount Equinox in the distance (right) and the homes and businesses of the Depot in the foreground. Amid older vernacular architecture, the railroad station stands out with its distinctive peak roof and other Victorian features. The large woodshed (left of station) provided the fuel for early wood-burning locomotives.

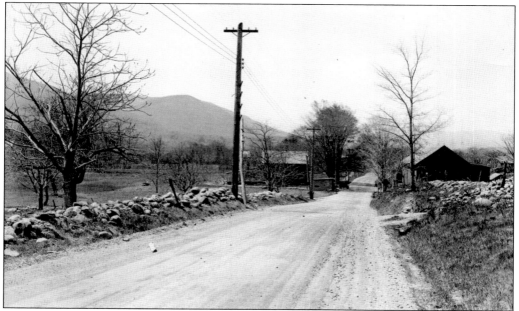

From the Depot, the highway begins its ascent up the mountain to the town of Peru. In this reverse perspective, heading down the mountain from the east, the dirt road (now paved Route 11/30) approaches the Depot another mile or more away. The farm buildings of the early 20th century have survived as commercial establishments today.

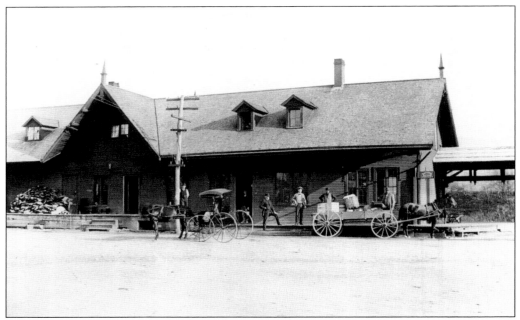

The anchor of the Depot—indeed its creator—was the railroad, its welcoming station a highly contemporary (at the time) Carpenter-Gothic Victorian structure. After passengers alighted from the train and freight was unloaded, horse-drawn carriages and wagons took over transportation to local destinations. Some inns of the area provided guests with this taxi service free of charge.

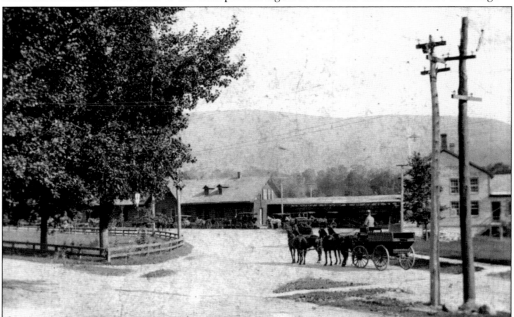

With a train in the station, traffic of all sorts was busy lining up: surreys with fringe on top, taxi wagons pulled by four-horse teams, and various other specialized vehicles. The park opposite the station, built in the 1870s, was an attractive feature that greeted travelers arriving to take in all of Manchester's beauties and benefits.

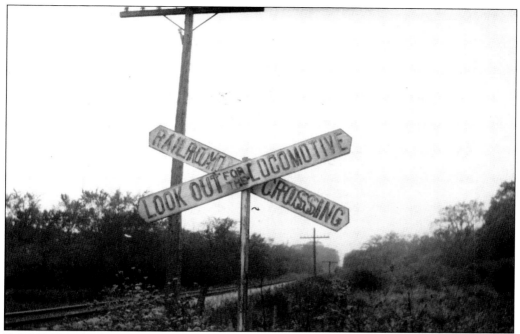

"LOOK OUT for the LOCOMOTIVE" says half the crossbuck sign. In the days before flashing red lights, signature bell ringing, and automatically lowered barriers, people riding in automobiles, in wagons, or on horseback were given an alternative—and, one might think, peculiarly modest—type of warning at the point where a dirt road intersected with the railroad tracks.

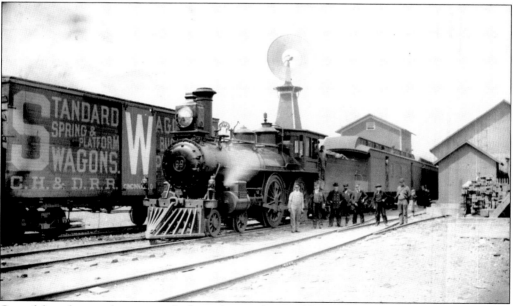

One of the substantial engines to look out for was this northbound Rutland Railroad locomotive at the Manchester Depot in 1900. The ancient 4-4-0 had been converted to burn coal (demonstrated by its straight stack), but some engines on the Bennington and Rutland Railroad were still burning wood. The large gable (to the right) is the end of the station's huge woodshed.

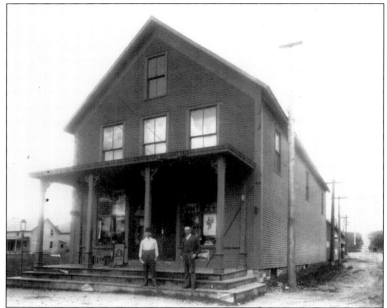

This building was the first store in the Depot. W.H. Fullerton established it after he built the marble works beside the railroad station in 1880. In this 1905 photograph, it is Manley's, dealers in general merchandise and lumber, with Thomas Healey (left) and Mark Manley out front. Subsequent commercial ventures at the site have included Walker & Marsh, Bradley's, Blackmers, and most recently, Firefly.

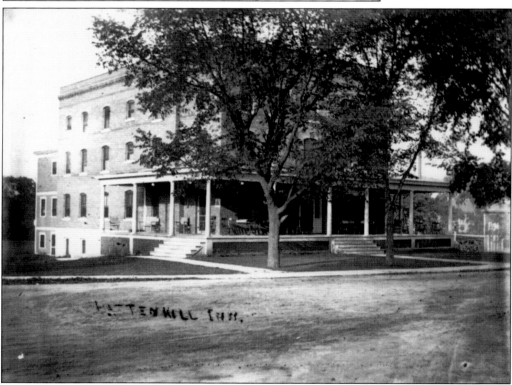

The Battenkill Inn, opened in 1908, was a classic railroad hotel built beside the depot and dependent on it for clientele. It boasted 24 rooms (a telephone in each) and 12 bathrooms. Its public dining room could seat 60. Among a series of name changes, this quite substantial structure was redubbed The Palace in 1973. The building was destroyed in a disastrous late-night fire in 1993.

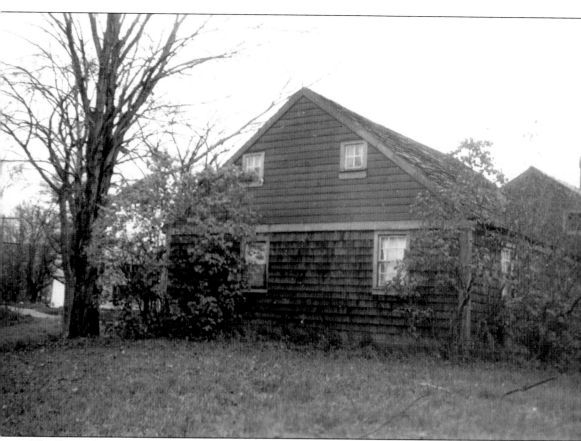

The Boorn house is linked to America's first wrongful murder conviction case—the subject of a spate of books. In 1812, Manchesterite Russell Colvin disappeared. It was known that Colvin and his brothers-in-law Jesse and Stephen Boorn were not on good terms. One Boorn relative reported dreams of Colvin's ghost, saying he'd been murdered and giving directions for finding his remains. Subsequently, bones (declared human by doctors) were dug up on the Boorn farm. In the investigation, Jesse fingered Stephen, who then confessed to murder. Although the judge at the 1819 trial directed the jurors not consider the confession, a guilty verdict was returned in less than an hour. Jesse was imprisoned as an accomplice, and Stephen received a sentence of death by hanging. Shortly before the scheduled execution, word came that the dead man was living in New Jersey. When he returned to Manchester, Colvin declared that the shackled man convicted of his murder had never harmed him. There followed a 50-gun salute in celebration of justice—the first shot fired by Stephen Boorn.

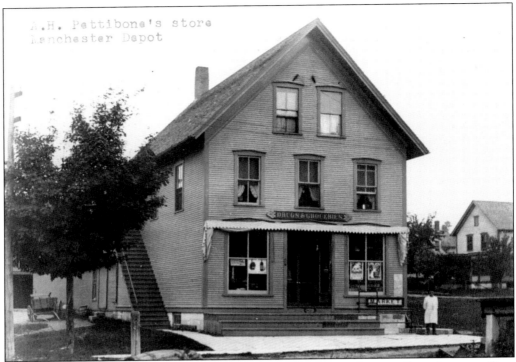

A.H. Pettibone's store, built in 1906 on Elm Street, was a grocery market as well as a drugstore. Over the years, a series of other drugstores—first Couture's, afterward Pratt's, and then Reed's—occupied the building. Later the space housed a Sears store and then an art gallery. For more than 20 years, it has been home to Al Ducci's Italian Pantry.

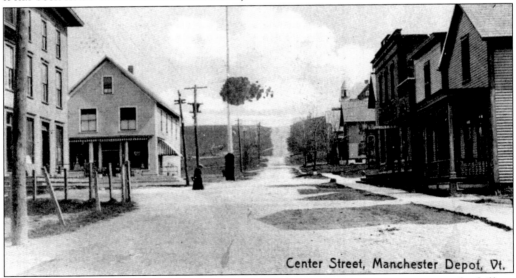

Center Street, Manchester Depot, Vt.

Called "Center Street" when it originated in 1873, this perspective gives a view up the hill on today's Highland Avenue, with Elm Street on the left in the middle distance. Many of these buildings still exist. With shops, businesses, and a theater in its history, this section of the Depot was long—and remains—a little hub of commercial activity.

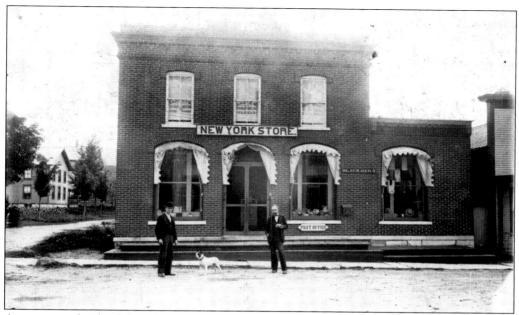

An imposing brick edifice, this building had more than one incarnation. With elegant awnings gracing its arched windows around 1875, it was Blackmers high-end emporium, signaled by its urban title, the New York Store. In his store, John Blackmer was the postmaster for the new US Post Office delivery zone designated Manchester Depot.

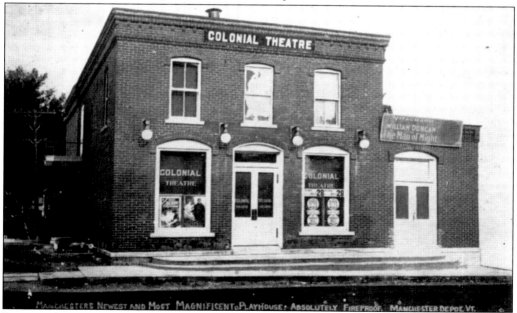

By 1919, featuring exterior globe lamps and an interior pressed-tin ceiling, this building had become the Colonial Theatre, touted as the town's "newest and most magnificent playhouse" and furthermore declared "absolutely fireproof." The Colonial showed films made by Vitagraph Studios, the most prolific among contenders within the nation's fledgling movie industry in the early part of the 20th century.

Lining Elm Street were some of the Depot's most handsome homes. The brown-shingled residence here, built in 1893, was owned in the early 1900s by John P. Jackson, manager of the Norcross-West marble finishing plant in the Depot. In 1870, John Blackmer had built the first house in the Depot and rightly foretold that a village would surround it.

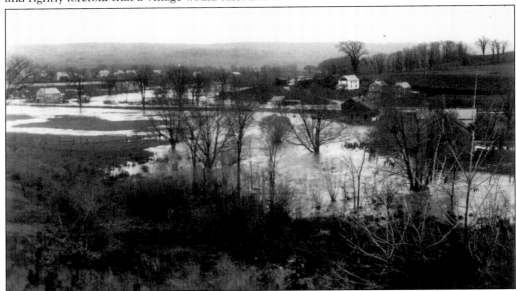

October 1927 saw unusually heavy rainfall in Vermont, and on two days in early November, still more rain fell on saturated ground, leading to what has been described as the greatest disaster in Vermont history. Throughout the state, bridges were washed away, and 84 people died. This view of the Depot at that time shows the extent to which the swollen waters of the Batten Kill inundated local land.

Two

HOUSES OF WORSHIP

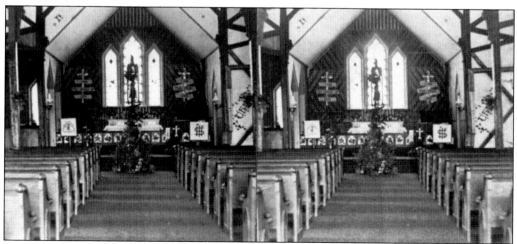

For the early settlers who found largely wilderness in southern Vermont, survival and taming this land were their primary objectives. Few professed any religion. Subsequent settlers brought their faith to Manchester, gradually establishing houses of worship. This photograph is of the interior of the original St. John's Chapel, the design of which was followed in the new chapel built in 1910.

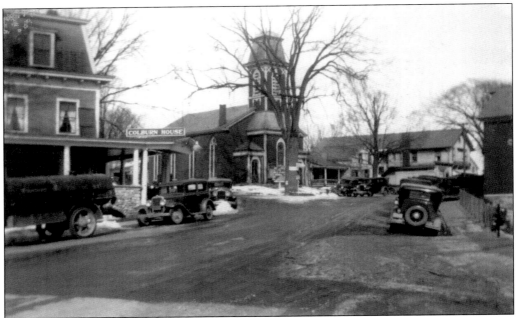

The First Baptist Church (center) was organized in 1781, and the members elected Elder Joseph Cornell pastor. He received the First Settled Minister's Right (a land grant) under the town charter. The original church, erected in 1785, stood on Meeting House Hill (the northwest corner of today's Factory Point Cemetery) on land donated by Timothy Mead. In 1833, the meeting voted to build a new church at Ames Corner, the intersection of Main and Bonnet Streets, where it remains today. The Gothic Revival structure, built of bricks hauled from Bennington, cost some $2,300. A marble platform was added in 1843. Improvements and alterations made over time included the bell tower, bell, and vestry, added in 1873. Its rare Johnson Tracker organ, which dates from 1896, was installed in 1926.

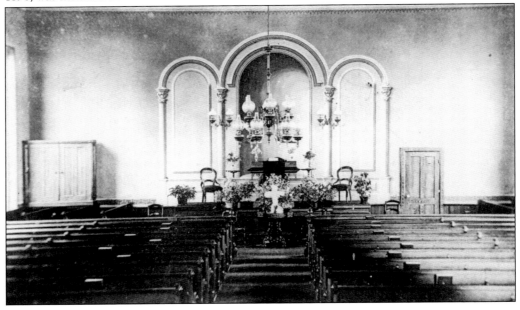

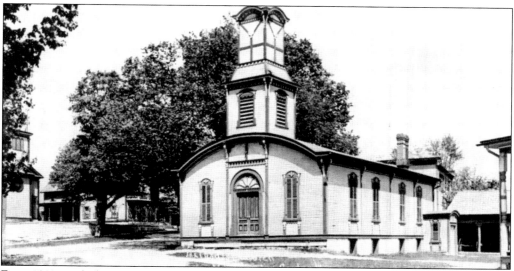

From 1811 until after 1875, Methodist pastors from nearby towns held services in Adams Hall in Manchester Center. Then some prominent Methodists formed a society organization and built a church on a Main Street lot purchased for $500. In 1883, a tin-roofed wooden church was built to seat 200, and in 1889, the parsonage was completed. In May 1940, the congregation disbanded the society and sold the buildings.

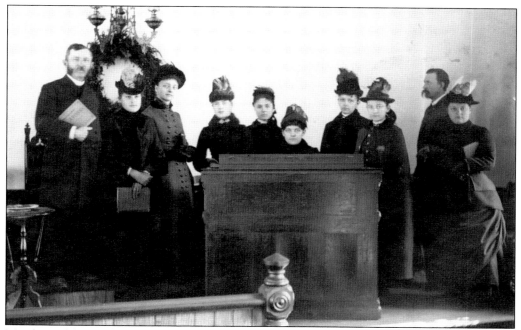

Members of the Methodist Church choir, as listed on the back of this c. 1885 photograph, are, from left to right, Rev. John E. Metcalf, Flora Marsh (Mrs. George Reed), Kate Hurd (Mrs. Fred Gilmore), Anna Ames (Mrs. Percy Williams), Jennie Benedict (Mrs. James Hamilton), Carrie Provan (Mrs. Rollin B. Smith), Helen Baldwin, Matie Metcalf, Edward O. Bentley, and Carrie Metcalf.

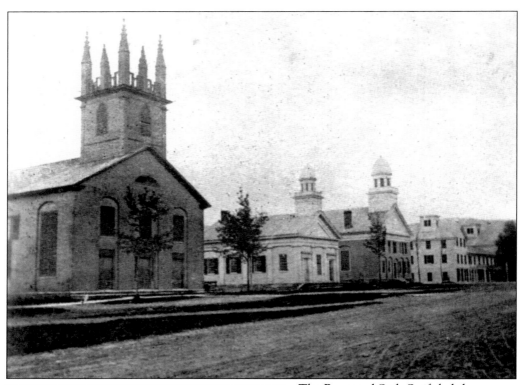

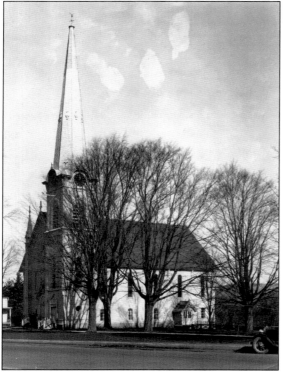

The Reverend Seth Swift led the organization of the Congregational Society in 1782. The church itself was organized in 1784. In 1825, both entities combined as the First Congregational Church. In 1829, the original meetinghouse was razed and replaced by the brick church. Funded by subscriptions, this church had galleries on three sides, one reserved in 1833 for Burr Seminary students. In 1871, laborers razed the badly deteriorated structure.

The new church and carriage sheds, built slightly north of the previous site, allowed Equinox House guests sitting on the front porch of the hotel an unobstructed view of the Green Mountains. Subscribers covered the $23,000 needed to build the new church. Facing west, the frame structure had clapboard siding, with the south corner featuring a 150-foot, three-stage octagonal spire with clock faces on four sides and culminating in a finial.

Between 1925 and 1935, the church interior underwent renovation. An early English stained-glass window, the gift of Mrs. J.N. Pew, was installed on the center-east wall of the sanctuary above the chancel and the choir stalls. On August 26, 1934, the church celebrated the 150th anniversary of its founding.

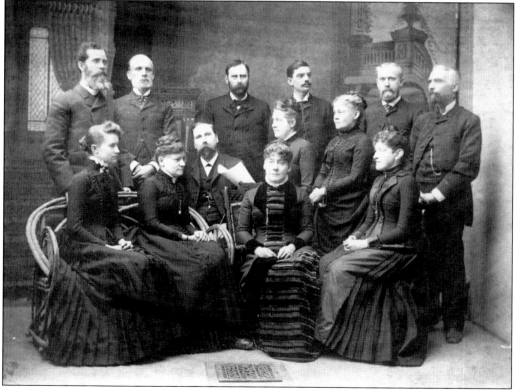

First Congregational Church choir members shown in this c. 1878 photograph are, from left to right, (first row) Mrs. J.W. Fowler, Mrs. George Swift, Mrs. David K. Simonds, Helen Black; (second row) George Swift, Mrs. George Smith, Mrs. Theodore Swift; (third row) Dr. Lewis H. Hemenway, George Smith, Theodore Swift, James D. Way, George L. Towsley, and David K. Simonds.

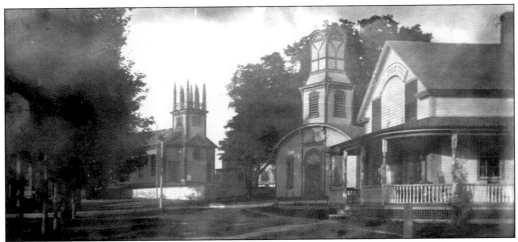

The Episcopal parish (left) organized during the first settlement and reorganized numerous times held services in the courthouse, homes, and schoolhouses. Under Vermont township grants, one of the three grants was a glebe for a minister of the Church of England. In 1782, twenty-four parishioners professed their faith in the Church of England by signing a document announcing the establishment of the Zion Parish. In 1820, a building lot was purchased in Mead's Mill (Manchester Center today) for $40 and a church erected for $4,500. In 1831, the bell tower was repaired and a new bell hung. In 1862, the church was enlarged and remodeled, and a stained-glass chancel window and a Trinity window were added. During the summer of 1886, the parish built a rectory. A parish house was bought and dedicated in 1939. Extensive renovations were undertaken in 2001.

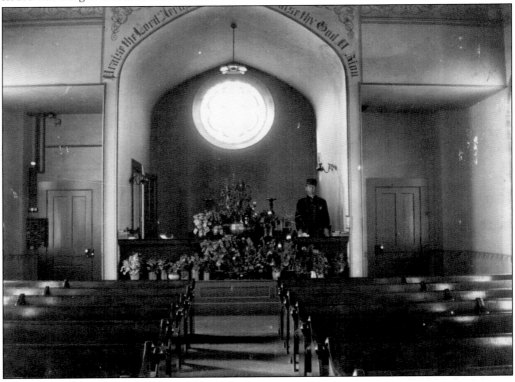

St. John's Chapel was built in the Village in 1867 in response to summer visitors' desire for convenient Episcopal services. Enough money was raised to purchase a lot on Seminary Avenue (below, at left) behind the Orvis Inn and to build the chapel at a cost of $5,000. However, the extremely damp building site led to premature deterioration of the structure, and in 1910, it was declared unsafe and dismantled. The new St. John's Chapel, built on Main Street in the Village, combined Greek and Gothic Revival styles. The former Cone & Swift Store, purchased and moved across Main Street, became the core of the new chapel. Materials and furnishings from the old chapel were incorporated in the new building. During July and August, St. John's serves as a diocesan mission, so designated in 1894.

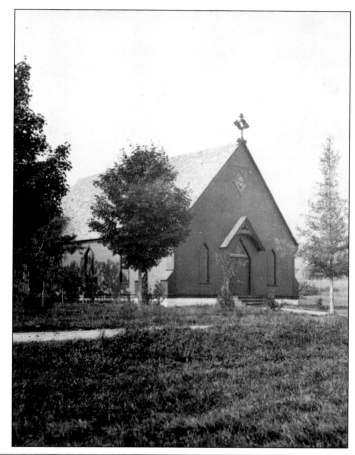

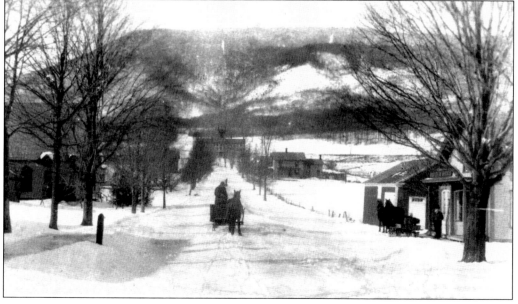

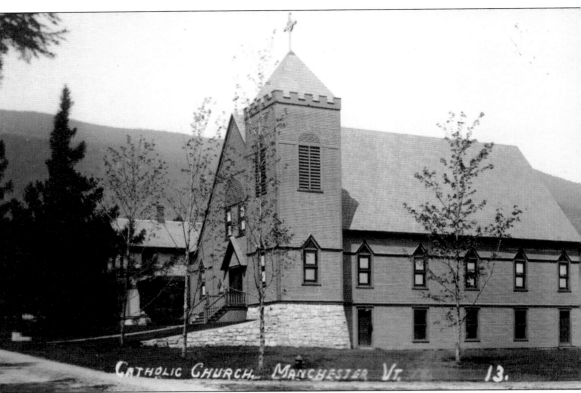

CATHOLIC CHURCH. MANCHESTER VT. 13.

Many of the Catholics who first came to southern Vermont were Irish immigrants drawn to work on the railroad and in the marble quarries. They were members of the first Catholic church community in the Northshire, organized in East Dorset some years before its sanctuary was built in 1874. To attend mass and receive the sacraments, Manchester Catholics would have had to travel to St. Jerome's in East Dorset for more than 20 years before their own town first saw a Catholic church in 1895. The Reverend John Dwyer, the initial resident pastor, oversaw the construction of St. Paul's at the corner of Seminary and Franklin Avenues. Three years later, a rectory was built next to the church, and by 1907, the combined indebtedness of $11,500 had been repaid. In the 1960s, the parish built a larger, modern church on Bonnet Street. The original St. Paul's buildings are now part of the Burr and Burton Academy campus.

In 1918, when the town had only a few Jewish families, Philip Cohen and Noah Kamenetsky, two men well versed in the teachings of the Torah and the Talmud, arranged discussions around a potbellied stove. Next, they spearheaded a series of meetings that led to the establishment of the Israel Congregation of Manchester in 1920. Its elected officers were H.H. Levin, president; Samuel Greenberg, vice president; A. Levin, treasurer; Nahum Kamber, secretary; and L. Cohen and Noah Kamenetsky, trustees. Shabbat and holiday services, directed by the elders, were held in several sequential locations made suitable for the Torah and other religious articles. One of those was space in a home on Elm Street (the white building). For decades, such places served as home for the congregation, until a building was renovated in 1964. A new synagogue was built on Route 7A North and dedicated in 1985.

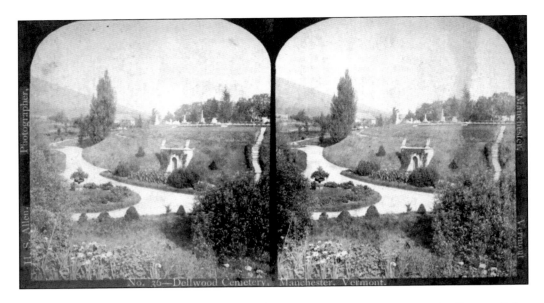

Prior to 1791, many people buried their loved ones in private cemeteries or the Factory Point Cemetery on Meeting House Hill. A third burial ground, provided by the original proprietors, was located where the courthouse stands today. During the War of 1812, recruiting officers removed smaller headstones and leveled the ground there to hold military parade practices; they moved the stones and remains to Dellwood Cemetery, south of the Village. Between 1850 and 1860, Dellwood was enlarged to 10 acres. In 1865, the Dellwood Cemetery Association was incorporated by an act of the Vermont legislature, 13 acres were added, and a $6,000 gift was received. Mark Skinner gave a new entrance gate in 1873 and, in 1875, two choice Italian marble sculptures: one a statue of Gabriel looking toward heaven as a personification of Resurrection, the other a figure of Mourning strewing flowers.

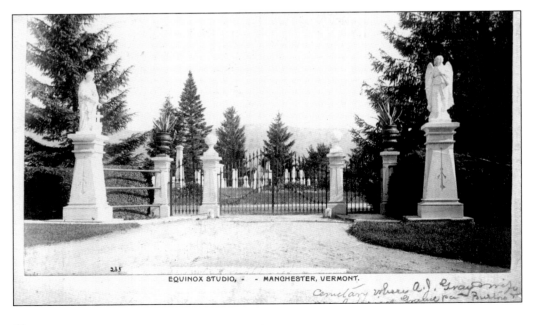

EQUINOX STUDIO, - - MANCHESTER, VERMONT.

Three

SCHOOLS

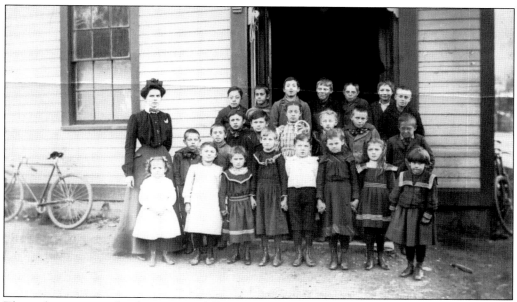

The early common schools were very different from what are known as elementary schools today. There were summer schools and winter schools and "man" or "woman" schools depending on the teacher. Many former schoolhouses are still in existence, having been repurposed as private homes. The oldest surviving one, built in 1837, is now on the Hildene property on River Road. Robert Todd Lincoln used it to store his father's congressional papers.

MANCHESTER.

Scale: 1⅓ Inches to the Mile.

Education was of vital importance to the early New England communities, and there is written evidence as early as 1776 of a schoolhouse near the West Road and Ways Lane. Vermont's first school law was enacted in 1782, and by 1791, there were nine school districts in Manchester; in 1860, there were 16. By the time the F.W. Beers *Atlas of Bennington County* was published in 1869, the number was down to 13. Originally, each school district was a municipal entity in itself with its own officers, grand list, and taxes. Funds to pay for the school were raised by a tax on the district's grand list and payment of 1¢ a day by the parents, which was known as "money raised on the scholar." In the early years, there were also numerous private schools conducted in homes, mainly attracting young women.

The Purdy District School in District No. 2 was located in the southwestern part of Manchester and named for the Purdy family, whose farms were nearby. This district was abolished before 1900, and when Route 7A was widened, the building was moved up the hill, where it became a private home.

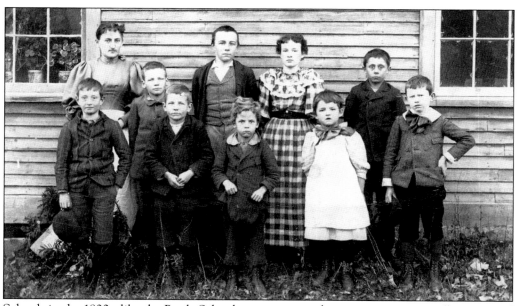

Schools in the 1800s, like the Purdy School, were very simple in construction, small in size, and usually only one room. The children were of all ages, and there was typically only one teacher. The teachers had to make do with a teacher's desk, a chair, and (occasionally) a broom.

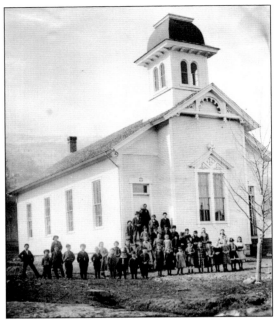

The schoolhouse in Manchester Village was originally located between the courthouse and the First Congregational Church on the village green. In 1870, when plans for a new church went forward, F.H. Orvis paid to have the schoolhouse moved to the West Road in the interest of improving the view from the Equinox House veranda for his guests. This building and all its contents were destroyed by fire in January 1877. A new schoolhouse (left) was quickly built to replace it in time for the fall 1877 opening of the school year.

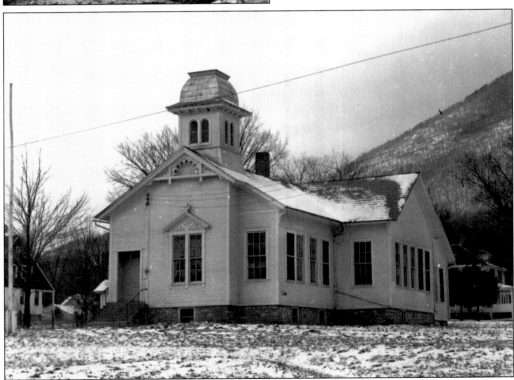

The new schoolhouse built in 1877 was moved to the back of the lot in 1905. The move allowed for the construction of a solid new foundation, a heating system, and indoor plumbing. Over the years, additions were made, and it went from being a one-room schoolhouse to having three rooms. It became a private residence after school consolidation in 1950.

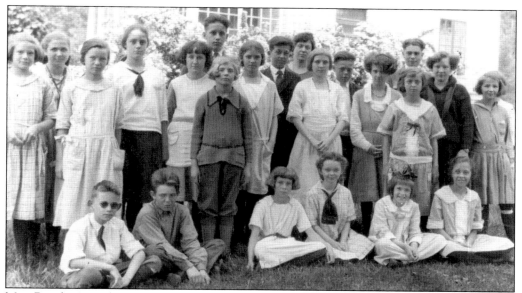

Miss Beecher's sixth-, seventh-, and eighth-grade students at the Village School in the 1920s included Catherine Hosley, Howard Wilcox, Dana Thompson (later the Manchester chief of police killed in a robbery in 1972 and for whom the recreation park is named), and (first row, right) Ruth Hard and Mildred Wilcox. The Wilcox children traveled to school by wagon and sleigh (in winter) from the family farm south of the Village.

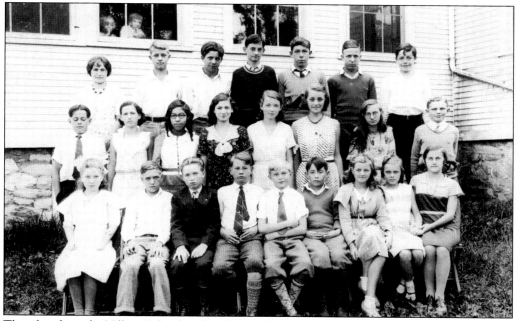

This class from the Village School in the 1930s includes, from left to right, (first row) Shirley Raw, John Wright, Milton Raw, Don Mattison, Ray Hulette, Alan Howe, Ray Allen, Barbara Butterfield, and Cecelia Bull; (second row) Al Lawrence, Flora Bolster, Elsie Blackwell, Eleanor ?, Caroline Moffitt, Helen Christie, Sara Matson, and Paul Gilmore; (third row) Alice Hewitt, Lawrence Wilcox, Harley Bell, Don Powers, Herb Randall, Charles Wright, and Henry Bessliure.

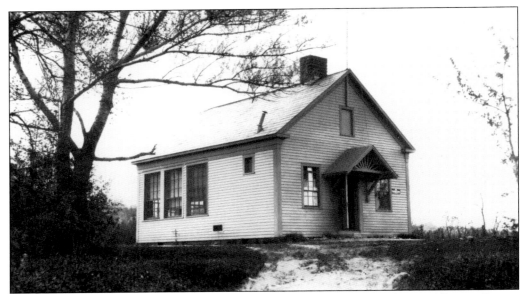

The West Road Schoolhouse was in District No. 4 on the road from Manchester Village to Dorset. There were several schoolhouses in the area over the years, all painted red. The most recent, known to have been in its current location in 1911, became a private home after 1950. The number and ages of students varied greatly, but the teachers were expected to keep them all busy.

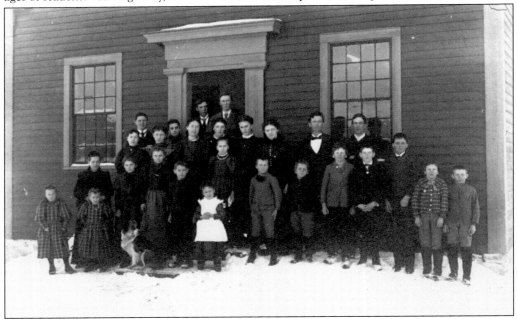

This c. 1900 photograph of the West Road School shows several members of local families, as the legend on the back indicates. Included are Peter McLaughlin, David Provan, Earl Buskirk, Mary Hanlon, Mamie Hanlon, Mary Mylott, Effie Buskirk, Maud Buskirk, Mary McLaughlin, Martin Wescott, Mrs. Frank (teacher), Edith Provan, Paul Provan, Eva Buskirk, Frank Lyon, Lester Thompson, Gilbert Thompson, Francis Hanlon, Andrew Provan, John Thompson, Bessie Lyon, and Helen Lyon.

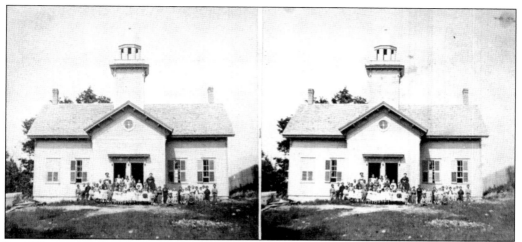

In 1829, a new school building was erected in the Mill District (Factory Point) just south of Zion Episcopal Church, replacing an earlier school that stood on Meeting House Hill near the cemetery. This schoolhouse, photographed around 1869, had two classrooms on the first floor and an assembly room above. It was sold in 1869 for $85 to Warren Adams, who moved it a short distance away and renamed it Adams Hall.

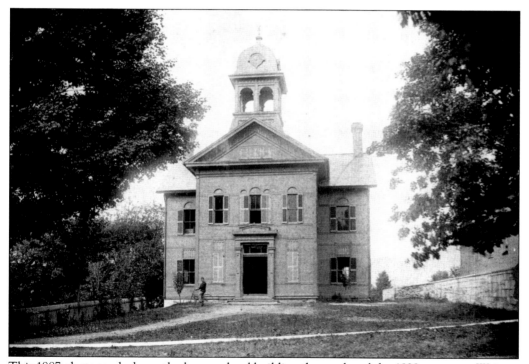

This 1887 photograph shows the larger school building that replaced the 1829 structure. Written on the back of this photograph are a former student's fond remembrances: "How many a thrashing have I received in this building. Oh, what good times I had there." The new building retained the belfry, which housed "one of the finest bells cast in America," according to a gentleman who collected bells manufactured in Troy, New York.

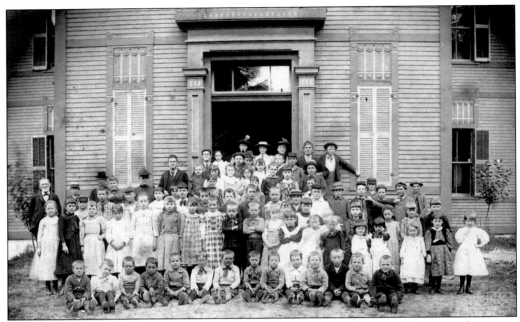

The Center School was the largest elementary school in Manchester and continued to serve District No. 9 until 1950. Though bigger than its predecessor, the new school needed to be enlarged several times and eventually had four classrooms. The building was demolished in 1969 to provide a parking lot for the Zion Episcopal Church.

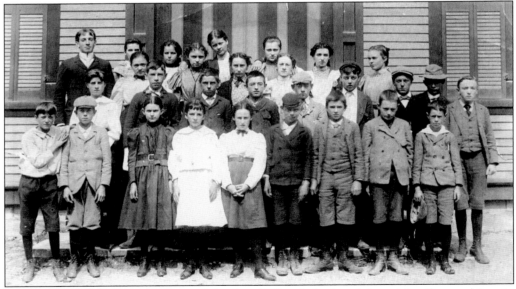

Second-grade students at the Center School in 1920 include, from left to right, (first row) Laurin Davis, Paul Fowler, Faith Lindsley, Maud Turner, Jenette Bowman, Reuben Taylor, Claude Williams, David Bulkley, and Frank Lugene; (second row) Bertha Anderson, Robert Anderson, Carl Buffon, Lugene Colson, Esther Froder, ? Warner, George Bentley, Nye Taylor, and Carl Langford; (third row) Delia Provanchen, May Wyman, Alice Sherwin, and Cora Hoyt; (fourth row) Ernest Whitney, Cora Fisher, Ethel Taylor, Edith Wright, Mabel Hopkins, Ethel Colson, and Carrie ?.

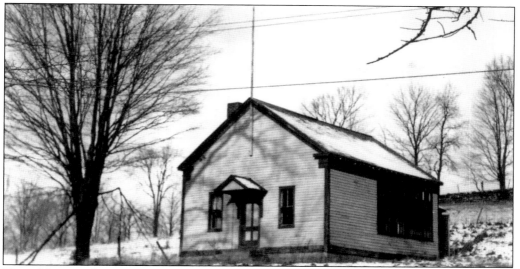

Named for one of Manchester's leading citizens—E.B. Hollister, who lived nearby—the Hollister School was built in 1868 as a one-room schoolhouse on old Route 7 between the Roberts and Bryant farms. It served the community north of Manchester in District No. 6, known as the Roberts District, until the 1940s when Route 7A was relocated to the east. The schoolhouse was demolished in the early 1950s, and some of its siding was used to build the original VFW.

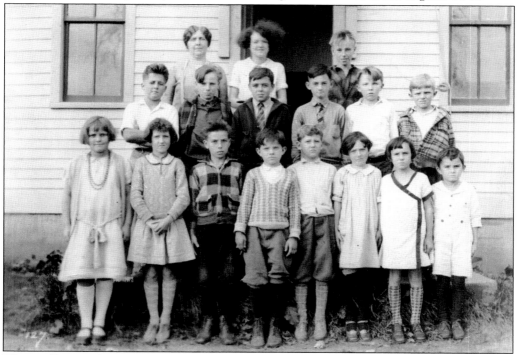

This Hollister School photograph from 1928 includes, from left to right, (first row) Dolores Charbonneau, Flora Bolster, Bennett Beattie, Clyde Bryant, Bobbie Bolster, Esther Blackmer, Ida Balch, and John Balch; (second row) Walter Hayes, Bob Beattie, George Balch, Don Powers, Fred Gilmore, and Paul Gilmore; (third row) Mrs. Ray Holt, Jesse Bolster, and Orrin Beattie.

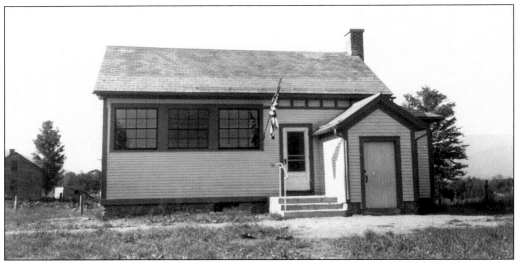

The East Manchester Schoolhouse served District No. 8. Schoolhouses existed in several locations, and the last building stood at the intersection of East Manchester Road and Routes 11/30. It was remodeled in 1947 and received a Superior School rating from the state board of education but was destroyed by fire the same year.

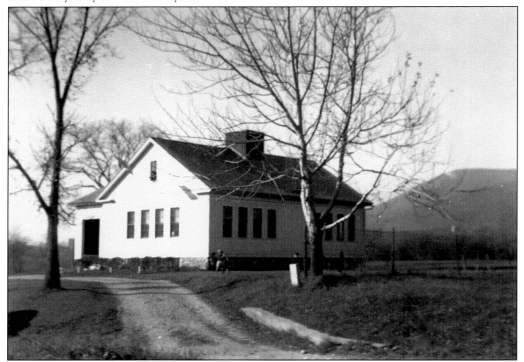

The Merriman School, constructed in the Depot area of Manchester in 1912, was the last neighborhood schoolhouse built in Manchester. With its two rooms, it served the nearby families who were engaged in the industries made profitable by the railroad, such as lumber and marble. It was named in honor of the Merriman family, whose generous donations toward the $9,000 cost helped build it.

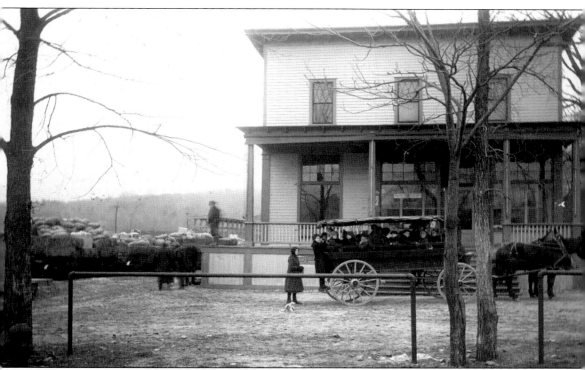

The precursor to the modern yellow school bus, this "school hack," as it was then called, served the Richville District in the early 1900s. Typically, such horse-drawn carriages had benches along the inside walls and canvas sides that could be rolled up and down. Children entered and exited from the rear to avoid frightening the horses. In this photograph, the school hack is parked in front of the Rich and Andrews Store in Richville. This area east of Manchester Village was named for the Rich Lumber Company, and many company employees and their families lived in the vicinity. Most children lived within walking distance of their one-room grammar school in this period, and if not, they hitched a ride on a farm wagon or, in winter, on a sled. In the 1800s, students at Burr and Burton Seminary would stay at the school throughout the term, returning home only for vacations. Later, students boarded during the week and returned home on the weekend.

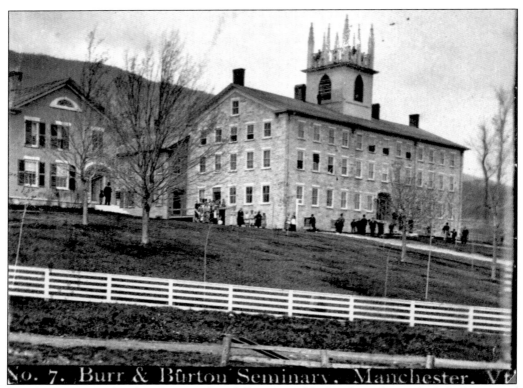

No. 7. Burr & Burton Seminary, Manchester, Vt.

Burr Seminary owed its foundation to Joseph Burr, a wealthy local merchant who left a bequest of $10,000 for the founding of a college preparatory school in Manchester. He stipulated, however, that the legacy must be matched dollar for dollar within five years through public subscription or be forfeited. In 1829, the school was incorporated by the Vermont state legislature. The first board of trustees worked tirelessly to raise the money, and in November 1832, the Seminary Building was completed. The first students arrived on May 15, 1833. The limestone used to build the thick walls came from a quarry on nearby Mount Equinox. Families paid tuition, room, and board until 1905, when it became the quasi-public school for Manchester and surrounding towns.

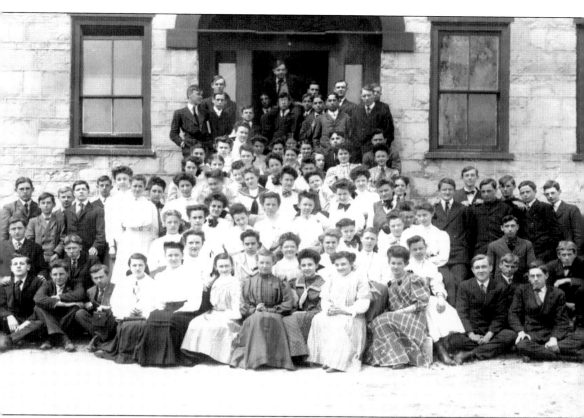

In 1880, students and faculty, gathered in front of the single school building for the first group photograph for the seminary. During the first 16 years, it was exclusively a school for young men intending to go on to higher education. In response to popular demand, 16 girls were educated informally at Burr Seminary in 1849. By 1850, there were 56 girls in attendance, with Cornelia Orvis as the preceptress (instructor). When Josiah K. Burton, one of Burr Seminary's founding trustees, died in 1853, he left a bequest to create a girls' seminary, with the provision that the funds be given to Burr Seminary for the same objective if a separate school could not be established. In 1859, young women were officially admitted, and in 1860, the name of the school was changed to Burr and Burton Seminary to honor its second founder.

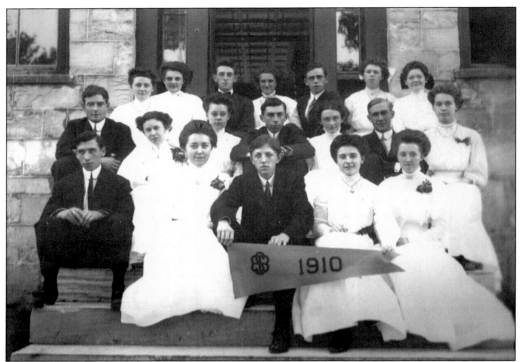

The size of the student body gradually increased, and the class of 1910 (shown here) was the first to enjoy electric power, though they had to pay extra for it. Boarding students were charged $5 a term for their room, and board was $3.50 a week. The curriculum had expanded to include business courses. Clifford Copping (front, center) was killed in France during World War I.

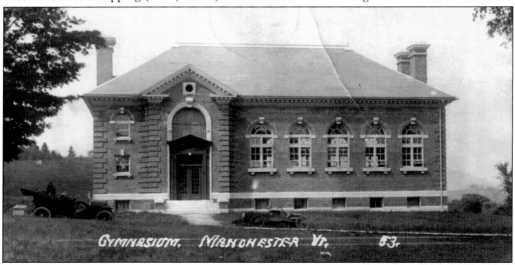

In 1913, a brick gymnasium that also served as a theater space became the first new building on campus since the headmaster's house was finished in 1834. The class of 1890 had formed an association to raise the money by subscription, as athletics were becoming increasingly popular. Alumnus A. Phelps Wyman of Chicago provided the original drawings, carried out by local architect A.H. Smith and local contractor Hiram Eggleston.

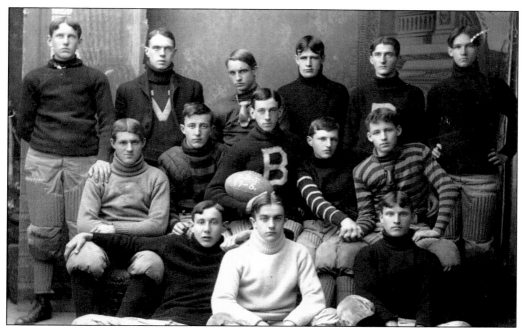

Although baseball was the first organized sports team at Burr and Burton, it was the football team that brought home the first state championship. Both the 1903 and 1905 teams were state champs, even though their practice field was little better than loosely graded pastureland. A $10,000 gift from alumnus and trustee W.B. Pettibone in 1925 made it possible to build a full-size athletic field in front of the school.

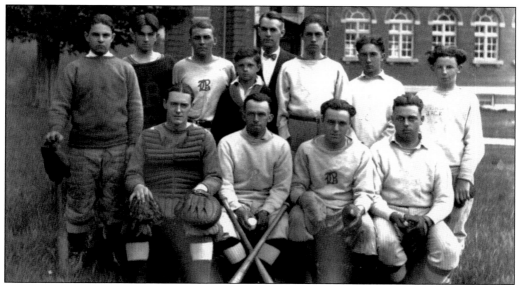

Baseball was the first organized sport in Manchester, and by 1889, the school had its own "Base Ball Association." Members of the 1920 baseball team posed on the field across from the new gym. From left to right are (first row) Hildreth Livingston, Charles Gaudette, Tony Lorenzo, Roger Wilcox; (second row) Raymond Mattison, Donald Mattison, Philip Connell, H. Kelton, Richard Hitchcock (coach), James Kelley, Fred Giddings, and Jack Cunningham.

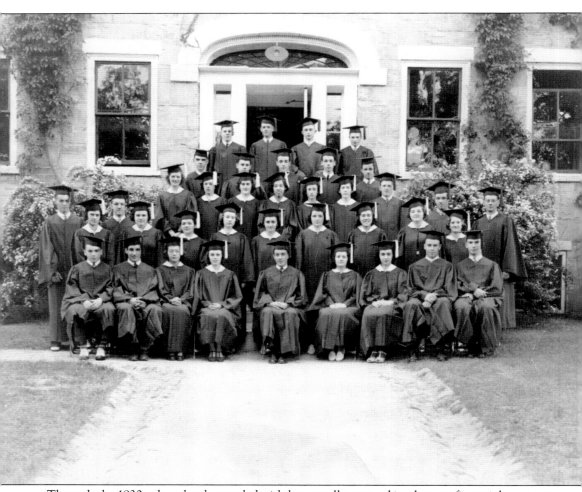

Through the 1930s, the school struggled with low enrollment and inadequate financial resources, but school spirit was not diminished. For the first time, the school colors green and gold were used, the first field hockey team was organized, and sports writers referred to the athletes as the "Bull Dogs." Members of Burr and Burton Seminary's class of 1938 included, from left to right, (first row) Clare Gove, Dick Smith, Peggy Ramsey, Barb Butterfield, Bill Barrows, Mary Fares, Mary Zullo, Leland Beebe, and Joyce Sumner; (second row) John West, Lillian Streeter, Don Harwood, Eileen Wilcox, Janice Matson, Jean Robinson, Emma Kilburn, Gerry Rice, Lillian Baker, Marion Grasso, Dot Baker, Larry Wilcox, and Don Mattison; (third row) Pat Allen, Ida Balch, Celia Bull, Elsie Blackwell, Connie Harrington, Hilda Young, and Franklin Fowler; (fourth row) Warner Fisher, Henry Koppen, William Gilbert, Charles Gilbert, and Clyde Bryant; (fifth row) Fred Koppen, Greeley Harwood, Ray Hulette, and Carl Nicholas.

Four

CLUBS AND
ORGANIZATIONS

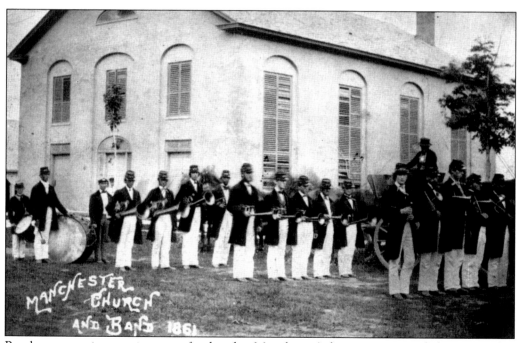

Bands were a prime music source for decades. Manchester's first was organized about 1845, but uniforms didn't materialize until 1861. Of these members of the Manchester Cornet Band (pictured in front of the First Congregational Church, in its earlier brick building), more than half would serve in the Civil War with the Equinox Guards, a unit made up chiefly of men from the town's three villages.

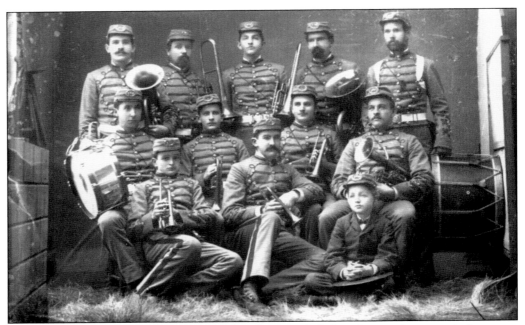

The uniforms worn by the musicians in this photograph (taken from a glass negative) seem to suggest a Civil War military band, but apart from the fact that at least two members appear to be too young for service other than playing musical instruments, the photograph was taken in 1875.

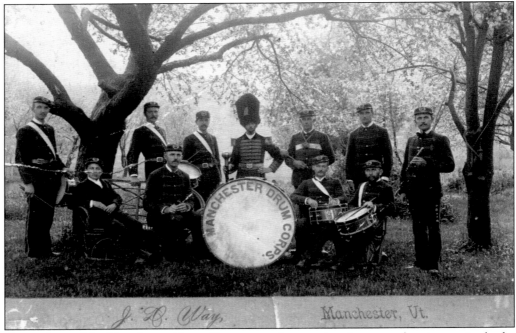

J. D. Way, Manchester, Vt.

Out in front of the Manchester Drum Corps was a drum major who sported an impressive busby and the traditional baton with dome head. The tall cylindrical fur cap known as a busby (the British name for a type of military headgear, originally Hungarian) was soon adopted in varying forms by units all across European nations and became highly popular with American bands.

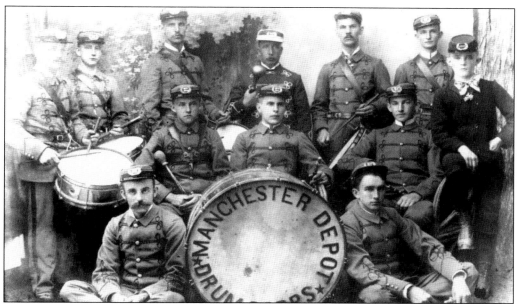

The Manchester Depot Drum Corps was a notable collection of brothers drawn largely from four families. The bandsmen are, from left to right, (first row) William Pettibone and Heman Dyer; (second row), Charles Curtis, Ned Pettibone, and Myron Pettibone; (third row) Waldo Williams, William Hicks, Clarence Curtis, James Bourne, Watson Curtis, Charles Bourne, and Albert Hicks.

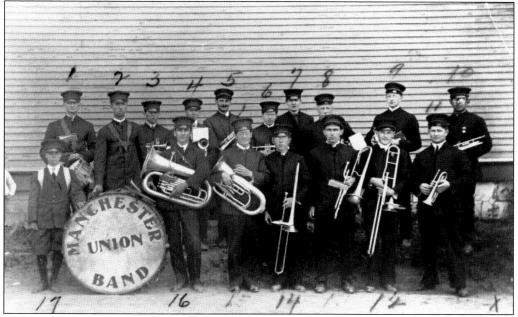

The Manchester Union Band, formed in 1904 in the Depot, was the town's longest-running unit of brass entertainment. It gave open-air concerts in all three villages, appeared regularly at town functions, played Memorial Day dirges at churches and cemeteries, serenaded at socials, oompah-pahed in parades, and even rendered service at the important Bondville Fair.

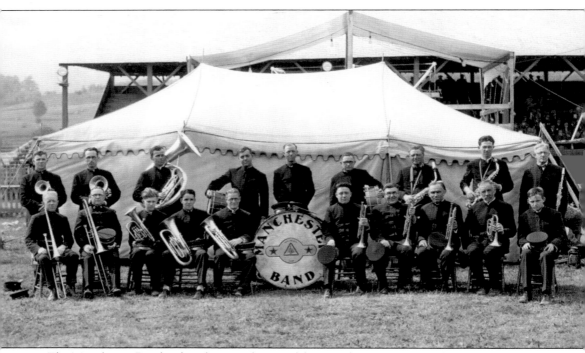

The Manchester Band, referred to as "a fixture of the Manchester Fair," poses here at the fairgrounds in September 1929. From left to right are (first row) P.W. Fowler, F. Hurley, R.O. Whitman, W. Adams, H.L. Adams (leader), Napoleon Ianni (director), W. Andrews, H.E. Taylor, N.M. Canfield, and E. Reynolds; (second row) A. Roberts, R.C. Brewster, R. Rowley, H. Amidon, R.L. Anderson, R.O. Bugbee, E.H. Swift, H. Wilcox, and L.W. Dennison. The musicians sported dark uniforms at winter performances and white ones in summer. The band, revived after World War I, was self-supporting through its sponsorship of annual carnivals, but in 1926, it had to ask the town for money in order to engage Director Ianni from Rutland at his "reasonable" $7-a-week rate. Ianni would provide music instruction in Manchester (later at the elementary school) for decades afterward.

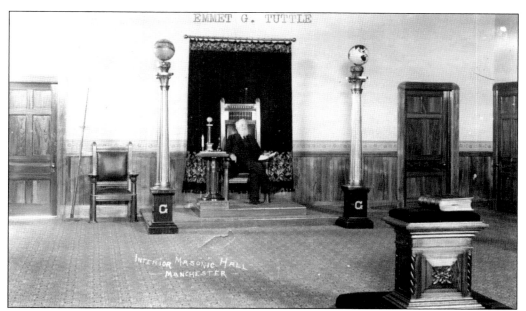

Masons were active in Manchester as early as 1785. The Adoniram Lodge No. 46, the second Masonic lodge in Manchester, was originally founded in Dorset in 1818, then moved to Manchester, and was suspended in 1831 by the Grand Lodge during the anti-Masonic period, when Vermont's Masonic lodges took a devastating toll. Later reconstituted, this lodge was in existence for a total of 32 years.

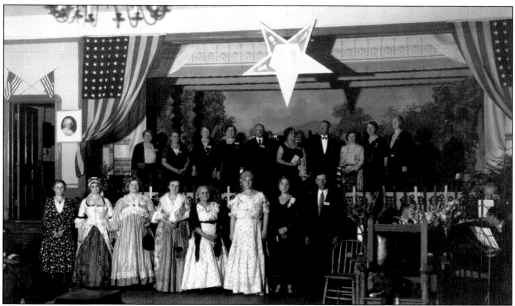

At the 38th Annual Meeting of District No. 1 of the Order of the Eastern Star in 1932, members entertained state officials (on stage) at the Union Opera House. Costumed Manchester members are, from left to right, Edna L. Swift, E. Estella Provan, Ethel M. Bennett, Anna H. Pratt, Helen M. Andrews, Mabel B. Lawrence, and Jennie R. Griffith (along with Lawrence A. Wade). Membership, 31 in 1885, had grown to 150.

The group in this photograph—two men, 13 women, and a female toddler—is identified as the Women's Christian Temperance Union (WCTU). Throughout Vermont, the religious impetus of the Great Awakening, beginning in 1850, fueled the prohibition movement. The local WCTU chapter was formed in 1885. It invited Anti-Saloon League speakers to Manchester and in 1906 spearheaded "No License" rallies in town.

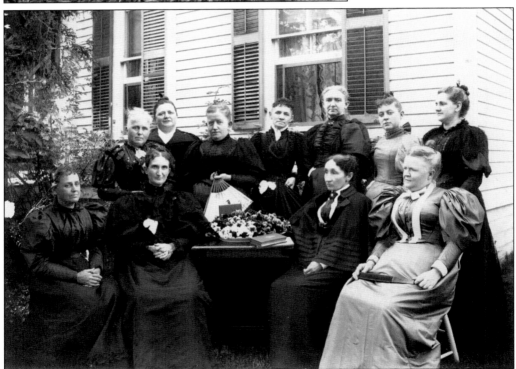

As many as 14 women, wives of prominent local businessmen and residents of the Village and the Depot, initiated the Shakespeare Club sometime in the 1890s. Here some of them meet outdoors on a hot summer day with flowers, fans, and (presumably) a copy of the Bard's play under discussion. Details of their meetings and the duration of the organization are, alas, lost in the mists of time.

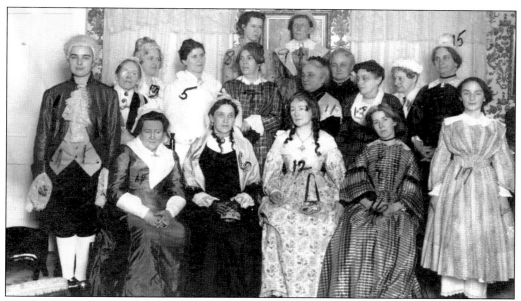

Monday Club members fashioned a "Colonial Tea" in February 1909. Attendees were, from left to right, (first row) Mrs. E.C. Orvis, Harriet Graves, Mary Robbins, Sarah McCurdy, and Helen Hawley Hubbard; (second row) Helen Perkins Pearson, Frances Fowler, Mrs. E.L. Wyman, Mrs. Loveland Munson, Hermione Canfield, Mrs. Lewis Hemenway, Mrs. George A. Lawrence, Minnie Cunningham, and Mary Roe; (third row) Edna Orvis Williams, Mrs. E.C. Perkins (the hostess), and Wilhelmena Hawley.

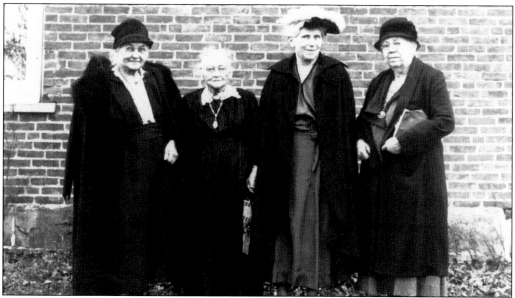

At 115 years, the Monday Club, the first women's group, is the town's oldest continuous organization. Here, four of the original 16 members—left to right, Eliza Lawrence, Minnie Cunningham, Mary E. Munson, and Hermione Canfield—celebrate the club's 40th anniversary in November 1935. Having earlier addressed the Peasant Revolt of 1377 and the lives of White House families, the Monday Club met 16 times throughout 2010 to examine "Women as Pioneers" in myriad realms.

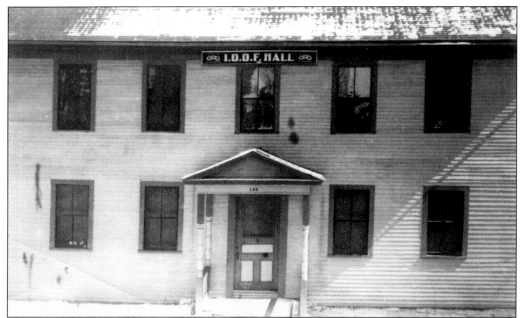

The sign "I.O.O.F. Hall" announces the Manchester Depot home of Hope Lodge No. 50 (built in 1905) of the Independent Order of Odd Fellows. The I.O.O.F., a benevolent and fraternal organization for men, went through four incarnations in Manchester, beginning in 1849. Other branches of Hope Lodge were the Bear Mountain Encampment No. 2 and the Excelsior Rebekah Lodge founded in 1894.

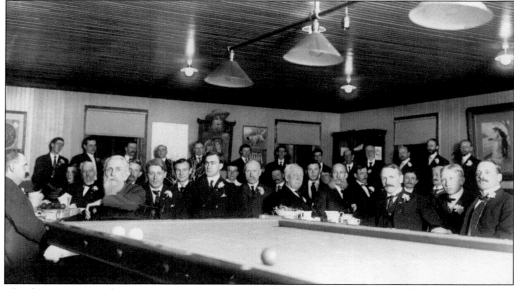

The first men's social organization in Manchester Village was the Columbus Club, which changed its name to Ondawa (the Indian name for the Batten Kill) in 1907. Fifty members from all parts of town met for card games, billiards, and pool at its Union Street clubhouse. Names familiar in Manchester turn up at this 1908 meeting: Edgerton, Hawley, Hard, McNaughton, Orvis, Pettibone, Reed, Simonds, and Wilcox.

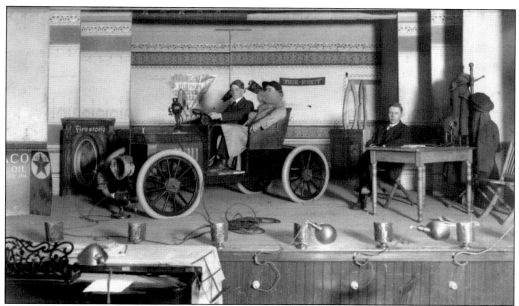

The Union Club existed from 1909 to 1926, offering cards, pool, and socializing. In the 1917 version of its annual minstrel show, one scene was a spoof of contemporary motorcar travel. Amid the array of gasoline and auto parts advertisements, the horseless carriage boasts flat tires. The wind in the passenger's beard is generated by an electric fan. Perhaps best of all, at stage front, the footlights of an earlier theatrical era are retrofitted with electricity. In another act in the same show, the Union Club Minstrels—left to right, Walter Hard, Leale Towsley, Harry Adams, and Edward Swift—took on then-President Woodrow Wilson. The four singers (below) were also billed as the Ondawa Quartet.

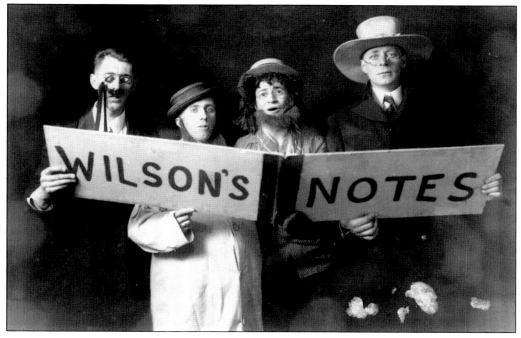

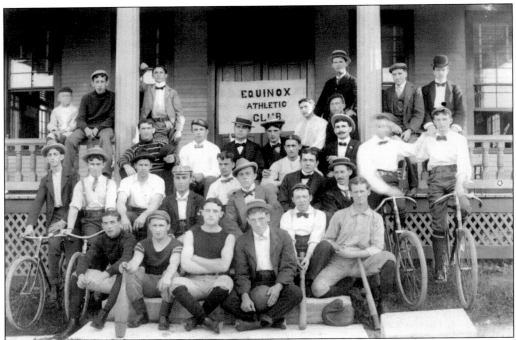

Baseball originated in the United States before the Civil War, and the earliest clubs in Manchester date from the 1870s. Over the years, the clubs played baseball under banners like Ondawa, Rip Van Winkle, and Equinox. Another group, the Equinox Athletic Club, had members (as their implements attest) who stretched themselves to sports beyond baseball, including biking, basketball, and bowling. The Manchester Base Ball Club, organized in the summer of 1927, regularly met teams from surrounding towns—and farther afield—at the fairgrounds. These members, pictured in July 1931 (below), are, from left to right, (first row) Robert Bushee, second baseman; Cozac Markey, third baseman; Harold Costori, right fielder; Dwight Lake, first baseman; Daley Rizio, centerfielder; Ralph Tinney, pitcher; and Jack Coakley, coach; (second row) W.A. Giffith, manager; Lynford Bourn, left fielder; R.C. Rowley, substitute; and Harold Eaton, shortstop.

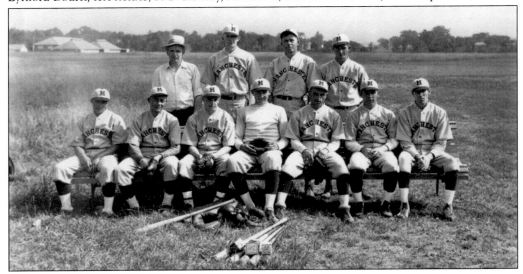

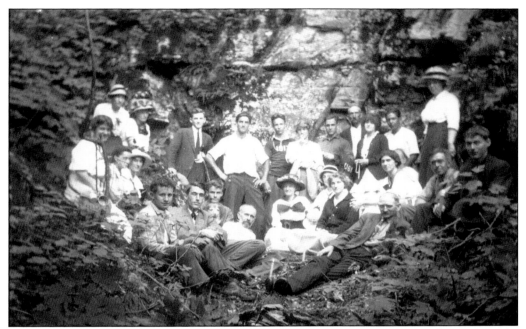

Members of the Green Mountain Club celebrate with a photo op after making their way to the Dorset Cave in 1913. The club's premier mission was to build a first-class connecting footpath on the mountains from Canada to Mount Greylock, south of the Vermont-Massachusetts border. Other aims included keeping young people at home on the farm and away from "temptations of sin and vice."

The Pacific Fire Company's 13 members, together with the Pacific Hose Company, constituted Factory Point's first firefighting corps, organized in 1877. By 1885, there were 70 volunteers. The company owned a single Button hand engine to pump water from a stream. The tannery whistle served as the fire alarm. The first firehouse was by the river near the Colburn House; it later moved to a lot facing Adams Park.

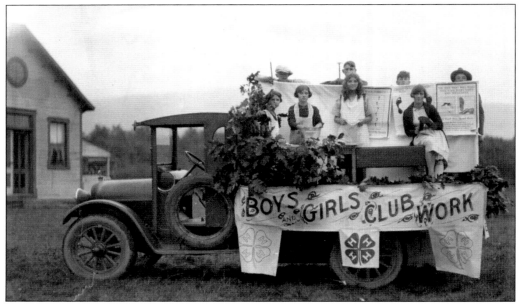

A 4-H float atop a 1920s parade wagon highlights the farm organization's many activities for both boys and girls. The first 4-H group in Manchester, founded in 1922, was the Battenkill Valley Club, soon to be joined by others—the Green Mountain Club, the Lye Brook Club, and the Hillside Workers Club.

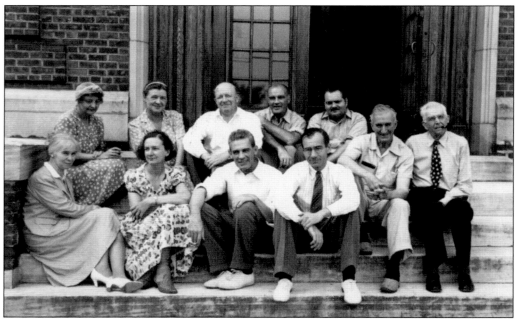

Some founders of Southern Vermont Artists around 1934 are seated in front of the old Burr and Burton gym, the scene of their first art shows. Their organization formed the nucleus of the Southern Vermont Arts Center. Pictured from left to right are (first row) Hilda Belcher, Bernadine Custer, Wallace W. Fahnestock, Norman Wright, Horace Brown, and John F. Lillie; (second row) Harriet G. Miller, Mary S. Powers, Herbert Meyer, Henry Schnakenberg, and Clay Bartlett.

Five

BUSINESSES
AND INDUSTRIES

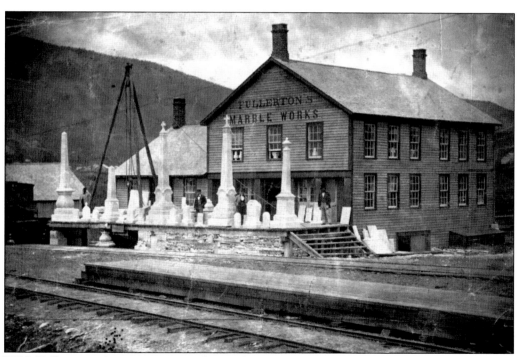

W.H. Fullerton, who came to Manchester from Dorset in 1866, opened his mill next to the railroad tracks in the Depot. He worked in marble and granite, designing, manufacturing, and installing statues, headstones, and monuments—among them the Soldiers Monument in the Village. Fullerton joined with the Gate City Marble Company to produce markers for Union soldiers who died in the Civil War, holding contracts for over 150,000 pieces.

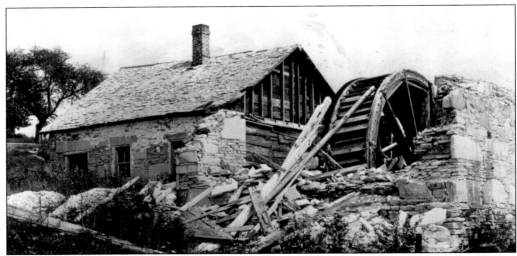

Lyman Way, operator of one of the first marble mills in Manchester, located his sawing mill on Glebe Brook, which provided enough waterpower to operate the machinery. His crude small mill turned out a small amount of finished product. The Way and the Chamberlain mills located here gave the name Marbleville to this part of the Village and to the modern Ways Lane.

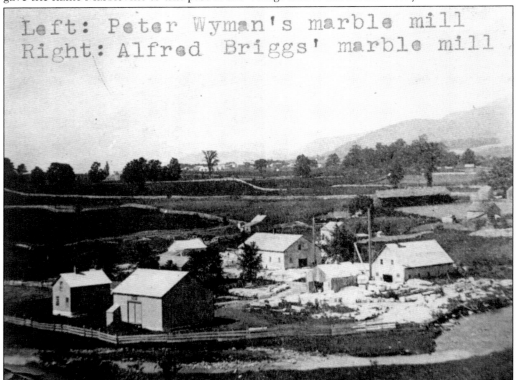

Alfred Briggs's mill was one of four that operated on the West Branch of the Batten Kill. Prior to the 1852 arrival of the railroad, most massive marble loads, often moved in the winter, were hauled by horse and oxen to the nearest water transport. Much scrap slab marble can be found in Manchester's house foundations and sidewalks.

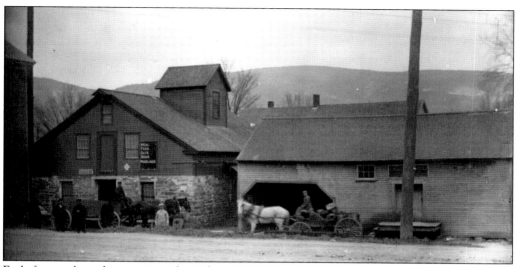

Early farmers brought grain in sacks to the gristmill for grinding into flour or meal—the coarseness of the grinding depending upon the intended use. Ground grain was used as cattle feed and in brewing to make a mash. The distance between the two millstones determined the grade of flour. Closer-set stones produced a finer flour. The miller kept a portion of the final product as payment. This mill was located in Factory Point (now Manchester Center) on the West Branch of the Batten Kill near the waterfalls. Discarded millstones can still be found today.

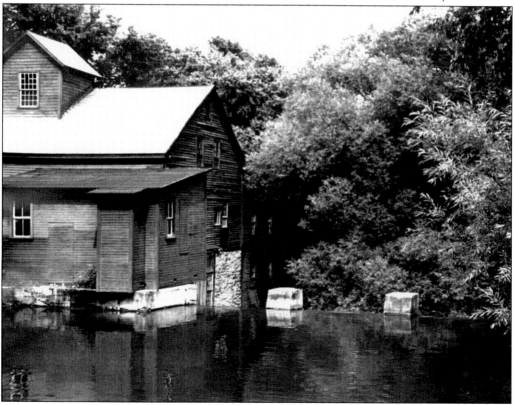

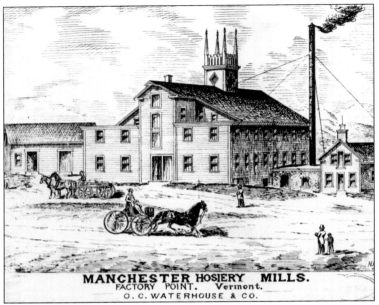

MANCHESTER HOSIERY MILLS.
FACTORY POINT. Vermont.
O. C. WATERHOUSE & CO.

Brought to America by the Colonists, the first frame knitting machines established hosiery manufacturing in New England. During the Civil War, cotton became scarce, causing the hosiery mills to close temporarily and eventually move to the South. This hosiery mill in Factory Point consisted of four buildings: a main structure three stories high, a boiler house, an engine room, and a picker room.

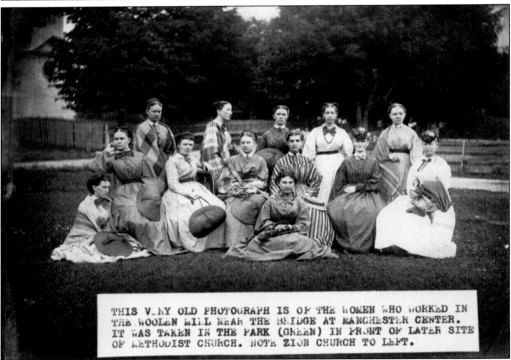

THIS VERY OLD PHOTOGRAPH IS OF THE WOMEN WHO WORKED IN THE WOOLEN MILL NEAR THE BRIDGE AT MANCHESTER CENTER. IT WAS TAKEN IN THE PARK (GREEN) IN FRONT OF LATER SITE OF METHODIST CHURCH. NOTE ZION CHURCH TO LEFT.

Early Manchester farm women spun their own wool until around 1800, when commercial wool production began in a mill located on the West Branch, a tributary of the Batten Kill in Factory Point. The 1824 tariff on woolens imported from England supported the rapid growth of the woolen industry in Vermont, but prices fell when the tariff was eliminated in 1846. Nonetheless, production continued in Manchester, as this photograph of woolen mill workers on holiday around 1890 attests.

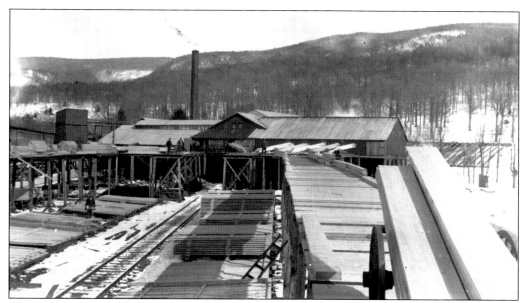

Though short-lived (1912–1920), the Rich Lumber Company was one of the area's largest lumber operations, cutting and shipping millions of board feet of lumber in its brief life. Here, boards are stacked high beside the company's rail line, which ran directly into the mill. The settlement the company built for its workers and managers was known as Richville, a name that survives today in Richville Road.

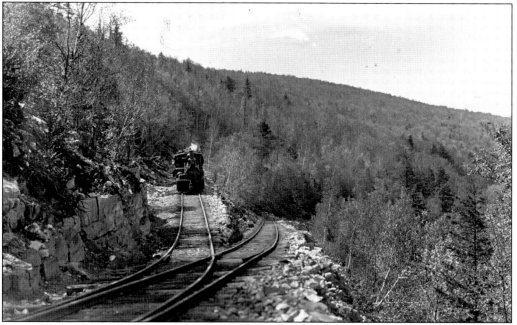

Rich Lumber's 16-mile-long railroad was built in 1913 and, by 1915, was transporting logs from 12,000 acres in Manchester, Winhall, and Sunderland to the mill. The train first proceeded forward and then backed up on a switchback track (seen here), crisscrossing the steep mountainside to access timber above and in a reverse dance to bring it down to the valley.

Once the loaded trains reached the mill, the logs were dumped into the mill pond with a big splash. A 1919 fire consumed the company's mill buildings and spelled the end of Rich Lumber in Manchester, a major player in local industry for seven years and a business entity with a 20-year history in New York State.

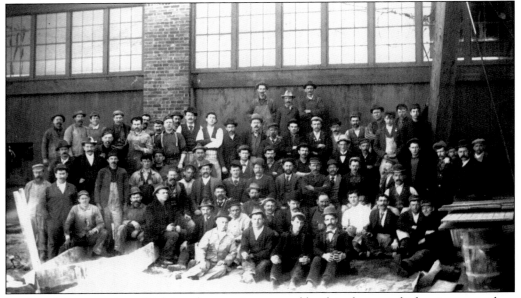

Just how big an employer Rich Lumber was is suggested by this photograph showing more than 70 hands inside the company mill. Additional workers manned the railroad, and sizable crews worked the timber-cutting operations in the woods. Besides the mill, the company constructed an office building, a store, and houses of officers and employees.

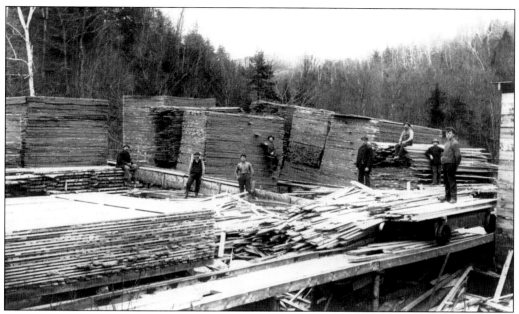

A view of lumber storage at Rich gives a clear picture of the scale and importance of the enterprise. These workers are dwarfed by the material around them that has come from the forest, been cut into lumber at the mill, and will soon be shipped via the Rutland Railroad to customers afar.

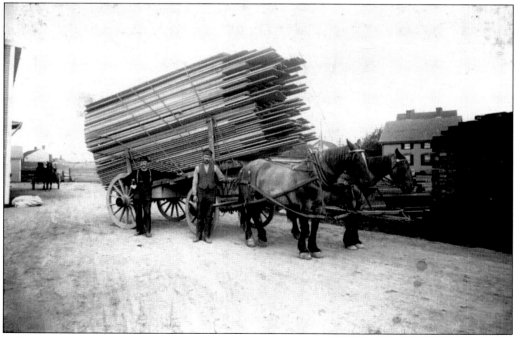

Still another form of lumber transportation in earlier times was this massive load of multi-length boards bound at an angle (not to interfere with the horsepower) atop a wagon with seriously sturdy wheels. There's a big job ahead for the equine team, not to mention the initial work of the laborers who loaded the wagon.

O.G. Felt opened his shoemaking shop on the east side of Main Street in Manchester Village in 1875. When he began his trade, Felt was using essentially the same tools that shoemakers had for centuries, but the gradual introduction of specialized machinery in the late 1800s drastically changed his business. Once the game of golf arrived in the late 1890s, Felt provided the hob nails that gave players' shoes the traction needed. He continued to make shoes in his small shop until he retired in 1928.

The tall smoke stack that marked the location of the town's only tannery was built in Manchester Center near the Batten Kill in the 1850s. It was over 60 feet in height and constructed of an estimated 100,000 bricks. The old landmark was razed in the early 1900s and the bricks purchased by the Dellwood Cemetery Association.

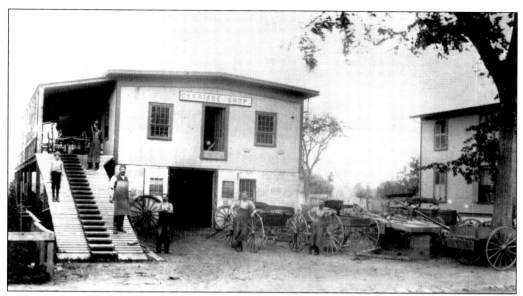

Lugene's Carriage Shop (1880–1890), located on Main Street in Manchester Center just north of Thayer's Tavern, did a brisk business before the advent of the automobile. Carriages were built on the second floor and, when completed, were lowered to street level with the aid of the ramp on the left. The building is still in existence and today houses an auto parts business.

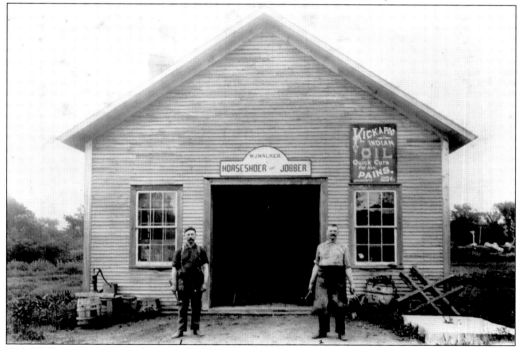

W.J. Walker was a "horseshoer and jobber" on the Flat Road in Manchester Depot shown in this c. 1890 photograph. Judging from the advertisement on the front of the building, he also sold "KickaPoo Indian Oil . . . Quick Cure." Walker's garage remained in its original location at the corner of Routes 11/30 and Center Hill Road for decades.

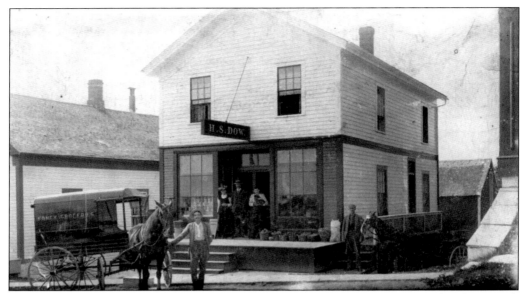

There were a number of small stores operating on Union Street in the late 1800s. This photograph from the 1890s shows the H.S. Dow store, a dry goods business next to the Music Hall. Dow had been a clerk with Cone & Swift in the Village before striking out on his own.

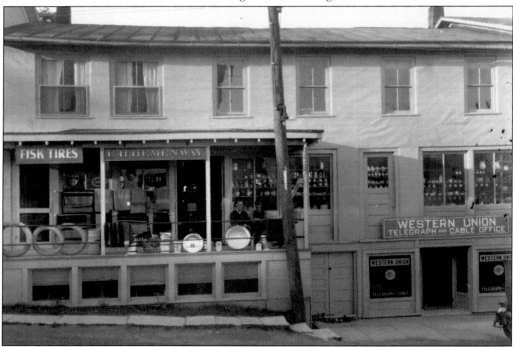

Hemenway's Hardware Store (pictured around 1910) was across the street from the Music Hall in buildings now part of the Equinox Hotel. Owned by Ned Hemenway, the business provided every type of product needed by local contractors, farmers, and mechanics. Ned was president of the Village in 1920, when the concrete road to Manchester Center was under construction; he was thrown out of office because the road was deemed "too wide."

In the late 1870s, Mary Orvis Marbury employed local women to tie the intricate flies used by fly fishermen who were customers of her father's company. Known fondly as the "Fly Room Girls," they are fashionably dressed for their portrait here around 1897. These girls would have helped Mary mount the exhibit panels of hand-tied flies, now in the American Museum of Fly Fishing in Manchester, that she took to the 1893 Chicago Exposition.

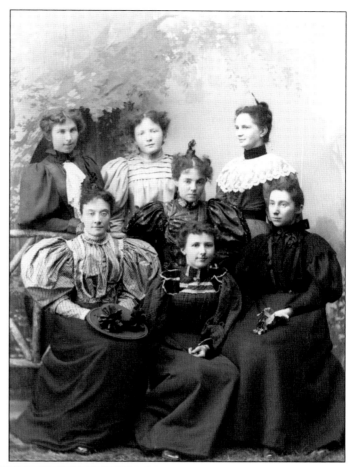

In 1856, Charles Orvis began his fly rod business in the basement of Equinox House, and by 1883, he was selling rods, tackle, and flies from the brick building next door that had originally been a bank. Charles manufactured the rods himself, and from 1874 on, they were produced in his building on Union Street.

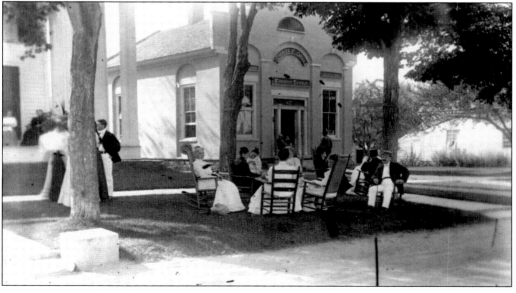

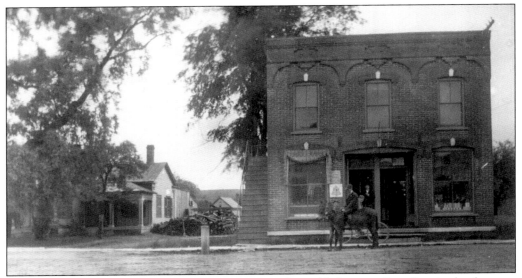

Lugene's Store had the look of the town's most upscale establishments. Standing in the doorway in this c. 1920 photograph are, from left to right, William Bradford and George Lugene; (out front) Louis Dupuis, Frank Lugene (on horseback), and Frank Smith. Today, patrons heading to Up For Breakfast can still climb the side stairway of this building to the second story.

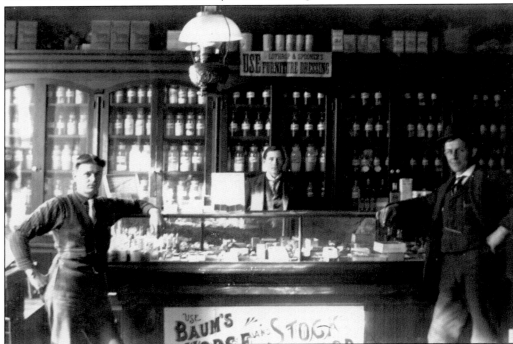

This unusual photograph from the early 1900s shows the shop interior of Pettibone's Drugstore on Elm Street in Manchester Depot. The dark wood cases with their glass doors held a vast array of potions, poisons, and herbs that would be mixed by the pharmacist. There were no controlled substances at the time, so customers took their chances. In addition to being a "dealer of drugs," Pettibone & Co. sold groceries, meats, and vegetables.

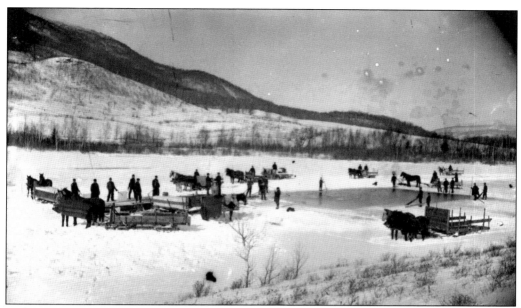

Ice harvesting was a not just a rural winter ritual in Manchester, it was a lucrative business. After Charles Orvis created Equinox Pond in 1856, ice was harvested there and stored year-round in icehouses insulated with sawdust. Horses pulled scrapers across the thick ice to remove the snow and allow the ice to freeze thick. Once it had reached optimum thickness, men would use saws and pickaxes to cut regular-sized blocks of ice and float them along a channel to be lifted to waiting sleds for transport. In 1877, the Equinox Ice Company stored 25,000 blocks of ice for delivery to customers in the Manchester and Dorset area. Throughout the 19th century, ice was a much sought after product because it provided the only reliable means of keeping food cold. Byron Eldred, shown around 1900 in his delivery wagon, had a thriving business delivering ice to local residents from his large icehouse on Richville Road.

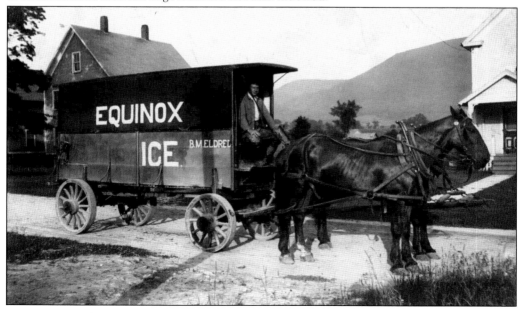

The chair peddler's wagon toted a dozen or more of his woodenwares—rockers, side chairs, and armchairs—all delivered to the home owner's door for personal perusal. Today's version of at-home shopping is the Internet, but without comparable hands-on vetting, return shipping may be necessary—a problem not on the horizon when these chairs were sold in Vermont in the 19th century.

This fellow's grocery wagon has been cleaned out, and he's stopping for a rest and perhaps some refreshment on Main Street in Manchester Center. He's delivered a whole range of fresh vegetables from the farm to in-town homes. A version of this sort of 1920s-era delivery service could still be seen in the Northshire in the early 1970s.

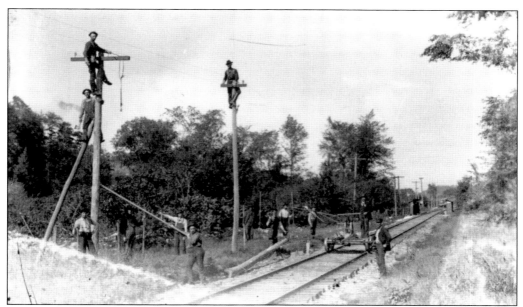

Here, a crew installs telegraph wires. Between 1846 and 1887, what grew to eight small telegraph companies vied for the modern communication business. In 1888, the new Green Mountain Telegraph Company, owned by J.E. McNaughton of Barnumville and E.G. Bacon, linked all offices on the Western Union line, extending it over the mountain from Barnumville to 12 towns and as far away as Bellows Falls.

Harry McGuffin mans the switchboard at the telephone company office. A handful of early phones existed in town in the 1880s. By 1918, the New England Telephone Company had a local office. Callers conveyed the desired number to the operator, who plugged in the appropriate wire to make the connection. As clients increased, two-digit telephone numbers eventually moved to three digits (and more).

The arrival of the railroad allowed for fast transportation of freight and express shipments. Express companies multiplied, using the railroad as the core shipper while they provided collection and delivery services at both ends. At the Manchester Depot station around 1912, a loaded American Railway Express Agency sled is ready to start work. Before the influx of motorized vehicles, sleds provided winter transportation.

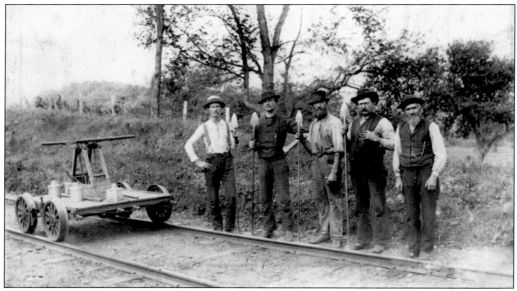

Gandy dancers, standing beside their hand-powered rig, carry their signature implements. These men made up the track gang for the quarry-to-mill short-line Manchester, Dorset, and Granville Railroad, which ran between South Dorset and Manchester Center. Crew members (left to right) Harley Fleming, Roby Jones, Michael Mylott, John Patterson, and Foreman Daniel Coffer straightened and shored up rails and ties.

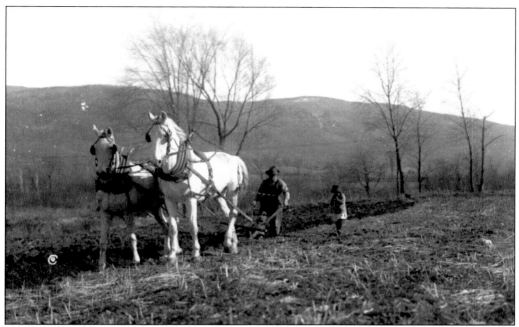

This farmer walked behind his two-horse plow, steering the single bottom-drawn plow and keeping the blade at the right soil depth to create a furrow. Later plows had seats and wheels and became gangplows with additional bottoms, and more horses were required to pull the heavy iron blades.

Once a labor-intensive manual activity, haying gradually became mechanized. On the Lathrop farm, windrowed dry hay is gathered onto a hay wagon using a hay loader, once drawn by horses and now by tractor, to be stored in a large barn for winter feeding. Today, in-field hay balers and field choppers produce round and rectangular hay bales that dot the landscape, but some manual labor is still required. (Courtesy of the Lathrop/Harwood family.)

After 1812, merino sheep farming dominated Vermont agriculture, peaking in the 1840s and steadily declining in the last half of the 19th century. The 1824 wool import tariff and worldwide markets for high-quality merino sheep kept the industry successful. The elimination of the wool tariff, the opening of the railroad to the West, and international wool competition ruined the industry. Farmers moved to more profitable dairy and diversified farming. (Courtesy of the Lathrop/Harwood family.)

As sheep farming declined, dairy farming became the primary source of agricultural income. The black-and-white cows in this photograph are Holstein-Friesian, first imported from Holland in 1852 and still the main breed in a Vermont herd. Their unexcelled milk production and adaptability to a wide range of environmental conditions are among the qualities that make Holsteins the breed of choice.

Six

PEOPLE

O.G. Felt (left) and his son Nate sport newly fashionable bicycles in the early 1890s. O.G. Felt came from Arlington in 1859, apprenticed himself to Manchester boot maker L.D. Coy, and by 1875, had his own cobbler's shop in Manchester Village. He also played trombone in the Manchester band in the 1880s.

Leonard Sargeant (1793–1880) was born in Dorset, the third son of Dr. John Sargeant, a veteran of the Revolutionary War. He went to Williams College when he was 14 and then studied law in Manchester with Judge Richard Skinner, who would become governor in 1820. In 1819, he assisted Judge Skinner in Manchester's most bizarre trial, the Boorn murder case. Sargeant's public career started soon afterward when he became state senator and state representative. He was lieutenant governor (1846–1848) and a member of the Constitutional Convention. His youngest sister, Delight Sargeant Boudinot, returned to Manchester with her six stepchildren after the death of her husband, Elias Boudinot, a Cherokee chief who was killed by a rival faction. In his 70s, Sargeant was a familiar figure in the Village, a tall, erect gentleman with white hair and a beard—often with his gun over his shoulder and his black dog Jim at his heels happily searching the woods for rabbits.

Richard Skinner (1778–1833)—born and educated in Litchfield, Connecticut—moved to Manchester in 1800. He was admitted to the Vermont Bar, built a house, married Fanny Pierpont, and was prominent as a lawyer and town leader. Career highlights included service as governor and chief justice of the Vermont Supreme Court. In 1829, he retired from public life, and four years later, he lost his life in a carriage accident.

Mark Skinner (1813–1887), son of Richard, was born in Manchester, graduated from Middlebury, trained at New Haven Law School, and was admitted to the Illinois Bar in 1836. His civic, legal, and philanthropic service was stellar. His son was killed in the Civil War, and in 1871, his Americana collection was destroyed in the great Chicago fire. He died at the Equinox House and is buried in Dellwood Cemetery.

Hubbel Lathrop (1819–1897)—a farmer, mill owner, and lifelong resident—lived in the southwest area of Manchester. He raised merino sheep during the height of the wool industry in Vermont, pasturing them on several hundred acres. He was active in church and town life and collected leather-bound books. He and his brother Eli stayed on the farm while brothers William and Chauncey went west and founded Racine, Wisconsin.

William Henry Lathrop (1855–1940), a recalcitrant Vermonter, inherited the Hubbel Lathrop farm. He completed the eclectic course of study and graduated from Burr and Burton Seminary in 1874. He played horn in Manchester bands. In 1901, he donated family relics to the Manchester and Vermont historical societies and to the Bennington Museum. Self-sufficient, he continued raising sheep into the 20th century.

The Reverend James Anderson (1798–1881) was called in 1829 to be pastor of the Manchester Congregational Church, and for 30 years, he presided over his congregation with great ability, bringing vitality to the intellectual and spiritual life of Manchester. One of his first duties was supervising the construction of a new church. He was a founder of Burr Seminary and a confidant of Dr. Joseph D. Wickham.

Dr. Joseph D. Wickham (1797–1891), a Yale graduate, arrived in Manchester in 1836 to become the second principal of the newly established Burr Seminary. He was principal for 25 years and chair of the board of trustees for another 30 years until his death in 1891. Despite his grave demeanor, he was a beloved teacher and mentor. His wife, Elizabeth, was also a cherished member of the community.

After studying at Burr Seminary, Franklin Orvis (1824–1900), eldest son of early proprietor Levi Orvis, went west to seek his fortune, but he returned in 1849 after the untimely death of his father. A natural entrepreneur, he transformed his father's home into the Equinox House in 1853, establishing Manchester as a destination resort. A man of boundless energy, he was also a newspaper owner and editor and a state senator.

Seen on the far right, Charles F. Orvis (1831–1915), fourth child of Levi, was at various times the village druggist, dentist, and postmaster; he also operated a large summer boardinghouse, the Orvis Inn. In 1856, he established the fly-fishing tackle business known as the Orvis Company after perfecting the manufacture of split-bamboo rods. He was as staunchly Democrat as his brother Franklin was Republican, and their battles were said to be legendary.

Mary Orvis Marbury (1856–1914), the youngest child of Charles Orvis, graduated from Burr and Burton Seminary in 1872 and soon after began to help her father run his fly-fishing business. Mary supervised the young women who made the flies, and in 1892, she published *Favorite Flies and Their Histories*, a long treatise on flies and fly tying that won acclaim at the 1893 World's Columbian Exposition in Chicago.

Louise Simonds (1874–1953) married George Orvis, a son of Franklin, following her graduation from Burr and Burton Seminary in 1890. After his death in 1917, she took charge of running the Equinox House, and in 1925, she hired Walter J. Travis to design the new golf course for the Equinox Links Club. She was the first woman to vote in Manchester and was, for many years, president of Manchester Village.

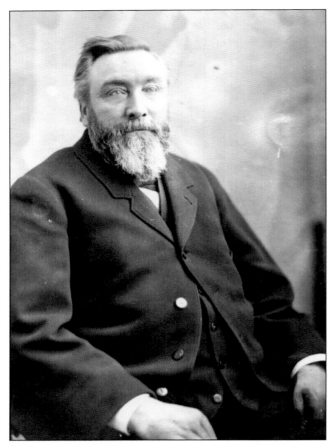

The Hawley family's presence in Manchester began in 1798 when Jabez Hawley arrived from Stratford, Connecticut. His descendants involved in the marble industry included E.J. (left), who patented a device that made it possible to cut larger blocks of marble, and Major, who managed a San Francisco marble plant until it was destroyed in the 1906 earthquake. E.J. (Eli Jabez/Jay) (1829–1914) owned much land, including 1,400 acres on Equinox Mountain that he sold to the Mohican Pulp and Paper Company. E.J. and his son Charles (1861–1933) developed Taconic Avenue in 1899. In 1885, Julia F. and Jessie O. Hawley, as guardians of their deceased sister's children, Sarah and Charles Cleghorn, rented Sans Souci on the West Road for 10 years and then lived in the Pink House (below) near Dellwood Cemetery. The Hawleys were civic leaders, and the women were founders of the Manchester Historical Society.

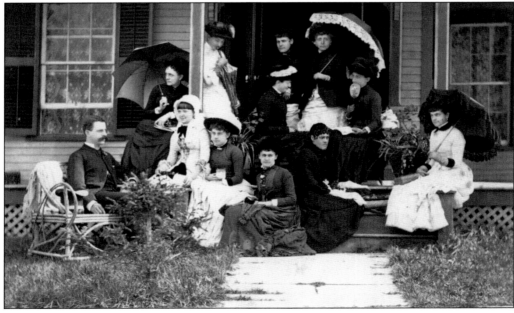

John S. Pettibone (1786–1872) was the son of Samuel, a Revolutionary War soldier who purchased the first house built in Manchester after it was confiscated from Tory Samuel Rose. A Middlebury College graduate, John was an officer in the War of 1812, represented Manchester in the state legislature, and served on the bench. A sheep farmer, he harrowed three-plus acres in 1862, just as he had in 1798.

Levi D. Coy dealt in books and stationery in Factory Point, as well as (separately) in boots and shoes, according to an 1860s business directory. In 1881, he was a member of the state senate. His book, *Personal Recollections*, published in 1897, was one source for the Bigelow-Otis history of the town. The Bennington Museum has a rare copy of his booklet that was donated by Nancy Otis.

For 75 years, the Miner family was influential in Manchester, beginning in 1835, when Ahiman L. Miner (1804–1886) came from Middletown Springs, Vermont. He attended Castleton Academy and was admitted to the Vermont Bar in 1832. In 1840, he spoke at the famous Stratton Whig Convention with Daniel Webster. He served several terms in the state legislature and held positions in various law offices as well as judgeships.

Susan Roberts Miner (1821–1913), second wife of Judge Miner, grew up in Factory Point. She recorded her memories of early homes and their inhabitants, which were published in a series of articles in the *Manchester Journal* in 1923. An Episcopalian, she joined a campaign to found an Episcopal chapel in the Village. She also organized a women's circulating library and was the first person to purchase a parcel post stamp in Manchester.

James P. Black (1833–1901) was a third-generation Manchester banker and the first head cashier at Factory Point National Bank, which was organized in 1883 with offices on Main Street. He resigned from the Battenkill National Bank in 1872 and lived in New York City for 10 years before returning to Manchester to follow in his family's footsteps. His father, William P. Black, was head cashier of the Battenkill Bank and the Battenkill National Bank and treasurer of the Burr and Burton Board of Trustees until his death in 1887. His grandfather William P. Black had been town clerk, town treasurer, and cashier of the First Manchester Bank (organized in 1832) and its successors, the Battenkill Bank and the Battenkill National Bank. Until 1888, the bank occupied the brick building north of the Equinox House. His great-grandfather Capt. Peter Black had come to Manchester in 1812 and kept a tavern on Main Street where many early settlers dined.

Dr. Edmond L. Wyman (1843–1934) was the son of a quarryman who arrived in Manchester in 1830. A graduate of the Homeopathic College of Medicine in New York, he wore a Prince Albert–style frock coat when making home visits in his horse and buggy (even after he owned one of the town's first cars). He was also president of the Factory Point National Bank, superintendent of Manchester schools, and justice of the peace.

David Kendall Simonds (1839–1917), known as D.K., was owner and editor of the *Manchester Journal* for more than 35 years. After serving with General Grant's Army of the Tennessee during the Civil War, he returned home to Manchester, where he was town clerk, state representative (1886), state senator (1888), Burr and Burton trustee, member of the Orleans County and Bennington County Bar Associations, Sunday School superintendent, and author.

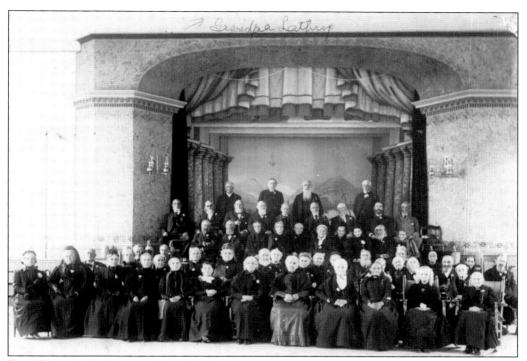

Franklin Orvis had a fondness for the elderly, and for years, he organized an annual party at the Equinox Music Hall for community members over the age of 70. In 1895, there were 57 seniors in attendance, including Mrs. Joseph D. Wickham (first row, left) and Icy Palmer (first row, third from right). The eldest was Mrs. Aaron Covey, age 90.

Little was known of her origins, but Icy Palmer (1824–1911), a Tuscarora Indian, lived in Manchester her entire life. Thanks to public and private support, she was able to lead an independent life into her 80s in the small house built for her. Daily, she walked the roads gathering wood; if she met someone, she turned away with bowed head. She is buried in Dellwood Cemetery.

The Hoyt sisters—soprano Frances (1868–1935), at left and below, and mezzo-soprano Grace (1871–1950)—were well known in turn-of-the-20th-century New York City as actresses, singers, and instrumentalists. They were soloists for John Philip Sousa, performing in more than 200 concerts during the band's transcontinental tour in the 1909 season. During World War I, they entertained American troops. Teachers of singing and dancing, they were also employed as models by Wallace Nutting for his hand-colored photographs. The Hoyts summered in Manchester every year at their mother's family home. The sisters were frequently billed in vaudeville and straight plays at the Music Hall in the Village, along with their brother Russell P. Hoyt Jr., another popular singer and entertainer.

Over the course of his distinguished career, Manchester native Loveland Munson (1843–1921) was a lawyer, member of the Vermont House and Senate, and both an associate judge and the chief judge of the Vermont Supreme Court. He was also a gifted writer and frequent editor of the *Manchester Journal*. In 1875, he delivered a speech on the early history of Manchester at the Music Hall on Union Street. His penultimate sentences that day can be applied equally well to the compilers of this 250th-anniversary book and to its early-21st-century local readers: "The life of the most favored individual is brief when compared with the probable duration of the community of which he is a part. We who now compose the corporate body will soon pass away, but the municipality may fulfill her thousand years. In that distant future, the space which separates us from the days of settlement will seem as nothing, and we who now commemorate the early history of the town will ourselves be reckoned among its early inhabitants."

Robert Todd Lincoln (1843–1926), the eldest son of Abraham and Mary Todd Lincoln (and the only one to survive to adulthood), also served his country in Garfield's cabinet and as a diplomat for Benjamin Harrison. As head of the Pullman Company, which embodied the apex of luxury in the heyday of railroad travel, he was one of the era's captains of industry. Having first visited Manchester as a young man, he later returned often to the home of his law partner Edward S. Isham. Lincoln purchased the land he turned into Hildene in 1902, and from 1911 until his death, his family summered there every year. A member of his Ekwanok Club foursome eulogized him: "Few men . . . have exerted upon a community an influence at once so strong, so gentle, and so kindly. In this village, he was more than a friend and benefactor; he was a strong and unusual character who enjoyed the universal respect of all who knew him." With houses draped in black bunting and all flags at half-staff, the town demonstratively mourned the passing of its most prominent part-time resident.

Lincoln Isham (1892–1971), grandson of Robert Todd Lincoln, is pictured in this c. 1930 photograph with his friend Walter Hard (left). Once, when he called for a probate appointment, he was told the court would be closed for the holiday. "What holiday?" he asked. "Lincoln's Birthday, of course—*you* should know," replied the judge. "Oh, I forgot—I'm as bad as Grandpa," said Linc, demonstrating the family's nonchalance vis-à-vis the presidential legacy.

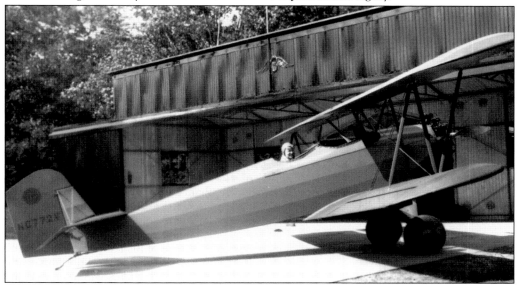

Mary Lincoln "Peggy" Beckwith (1898–1975) was the granddaughter of Robert Todd Lincoln. She inherited Hildene in 1938 and lived there until her death. Uninterested in clothes, her typical garb ran to overalls and an engineer's cap. A lover of children, dogs, cars, and airplanes, she took up flying in 1930 and owned several planes. Three years later, bowing to her grandmother's wishes, she gave up piloting.

Walter Hard (1882–1966) was a fifth-generation member of a Batten Kill Valley family. Although he departed Williams College in 1903 before graduating to take over his stricken father's drugstore business, his alma mater awarded him an honorary degree in 1932. Four years earlier, he'd published *Some Vermonters*, "a collection of Yankee characters" in verse. His nine volumes of poetry were marked by unrhymed lines and broken rhythms, which he likened to the Vermont landscape. Critic Louis Untermeyer ranked Hard among the historical best of New England poets. His newspaper columns and stories were written in a distinctly Vermont voice. Thanks to his books, which sold well, he was influential in broadening the state's reputation for its traditional rural ambiance. In 1935, he and his wife, author Margaret, sold the drugstore and became proprietors of the Johnny Appleseed Bookshop, which they ran for 30 years in the historic Orvis store building beside the Equinox Hotel. He also served five terms in the Vermont legislature. In this 1920s photograph, he is standing inside the Hard Drugstore.

The Roberts family is pictured in August 1882 at the Roberts homestead on North Road. From left to right are (first row) Betsy Roberts Reynolds, Myra Roberts Sinclair, Elizabeth Roberts Sanford, Mrs. Edward Roberts, Edward Roberts, Charles Roberts, and Dexter Roberts; (second row) Harry Cushman, Genevieve Roberts Bennett, Mrs. George M. Viall, Emmett G. Tuttle, Rev. Branard Kent, Lucy Roberts Kent, and Hanna Roberts; (third row) Mrs. Henry Roberts and Henry Roberts.

Nathaniel "Nat" Malcolm Canfield (1867–1942), a bandsman for 54 years, played first in his native Sunderland. In Manchester, he was the band's longest-serving president. At 73, this dedicated walker was still making the three-mile trip on foot from his home south of the Village to band practice. Such a diligent collector of weather records was he that, in days before on-air meteorologists, Nat was often called on for forecasts.

BIBLIOGRAPHY

Bigelow, Edwin L., and Nancy H. Otis. *Manchester, Vermont: A Pleasant Land Among the Mountains.* Manchester: The Town of Manchester, 1961.

Bort, Mary Hard. *Manchester. Memories of a Mountain Valley.* Manchester: Manchester Historical Society, 2005.

Coy, L.D. *Personal Recollections.* Manchester: Manchester Printing Company, 1897.

King, C.J. *Four Marys and a Jesse.* Manchester: Friends of Hildene, 2005.

Simonds, D.K. "A History of Manchester, Vermont." Typescript, 1915.

ABOUT THE SOCIETY

In the summer and autumn of 1897, Hermione Hitchcock Canfield, Julia Frances Hawley, and Wilhelmena Douglas Hawley conversed about forming the Manchester Historical Society. By October, officers were appointed, a meeting was held, and a constitution was decided upon. The officers were Pres. E.J. Hawley, First Vice Pres. Julia F. Hawley, Second Vice Pres. Anna J. Purdy, Corresponding Secretary Hermione H. Canfield, Recording Secretary Wilhelmena D. Hawley, and Treasurer Theodore Swift. Incorporation in the State of Vermont followed in 1898, with its purpose stated "of collecting and conserving information and documents relating to matters of historical interest; locating and marking, and if deemed advisable, acquiring title to places where historic events have occurred and placing thereon monuments or other memorials, and of receiving and holding in trust money or other property appropriate to the purpose of the Society; and providing a genealogy of the early settlers, and a convenient and reliable source of information concerning the town."

Topics at these early meetings often consisted of the reading of a family genealogy or a lively discussion of the occupants of houses that were familiar to everyone. During the 1920s, the society put on three costume balls, presented an exhibit of old articles to help Vermont's Sesquicentennial, and sponsored a historical play, *The Tin Peddler*. To celebrate its bicentennial in 1961, Manchester appropriated funds for a written history of Manchester and appointed a committee to oversee the celebration planning. In September 1961, *Manchester, Vermont: A Pleasant Land Among the Mountains*, written by Edwin L. Bigelow and Nancy Otis, became the first comprehensive history of Manchester. In 2011, the mission remains largely constant: to collect, preserve, and record the history of the community for future generations.

www.arcadiapublishing.com

Discover books about the town where you grew up, the cities where your friends and families live, the town where your parents met, or even that retirement spot you've been dreaming about. Our Web site provides history lovers with exclusive deals, advanced notification about new titles, e-mail alerts of author events, and much more.

MADE IN THE USA

Arcadia Publishing, the leading local history publisher in the United States, is committed to making history accessible and meaningful through publishing books that celebrate and preserve the heritage of America's people and places. Consistent with our mission to preserve history on a local level, this book was printed in South Carolina on American-made paper and manufactured entirely in the United States.

This book carries the accredited Forest Stewardship Council (FSC) label and is printed on 100 percent FSC-certified paper. Products carrying the FSC label are independently certified to assure consumers that they come from forests that are managed to meet the social, economic, and ecological needs of present and future generations.

FSC

Mixed Sources

Product group from well-managed forests and other controlled sources

Cert no. SW-COC-001530
www.fsc.org
© 1996 Forest Stewardship Council

Find *Your* Place in History.